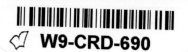

VOICES OF AMERICA

GOLDEN MEMORIES OF THE
Redwood Empire

Moving goods and people to and from the metropolitan area was a major goal of residents of the lush country north of San Francisco in the late-19th century. The process was not swift but it was steady as residents relied on ships and railroads to make the major connections, not only to the big city, but also to the growing communities in their relatively sparsely populated area. A map drawn in the 1870s shows the major rail and shipping facilities of Sonoma County. (Thompson 1887 Atlas of Sonoma County.)

VOICES OF AMERICA

GOLDEN MEMORIES OF THE
Redwood Empire

Lee Torliatt

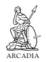

ARCADIA

Published by Arcadia Publishing,
an imprint of Tempus Publishing, Inc.
3047 N. Lincoln Ave., Suite 410
Chicago, IL 60657

Printed in Great Britain.

Library of Congress Catalog Card Number: 2001089138

For all general information contact Arcadia Publishing at:
Telephone 843-853-2070
Fax 843-853-0044
E-Mail sales@arcadiapublishing.com

For customer service and orders:
Toll-Free 1-888-313-2665

Visit us on the internet at http://www.arcadiapublishing.com

This map of Sonoma County shows the numerous cities circling Santa Rosa—the rapidly growing county seat. To the west lies Sebastopol and the Pacific Ocean; to the north, Healdsburg and Cloverdale; to the east, Sonoma; and to the south, Petaluma.

CONTENTS

ACKNOWLEDGMENTS

The many people, past and present, who helped with this book, include:

Minna Allegro
Michelle Berg
Dee Blackman
Sherman Boivin
William Borba
Darla Budworth
Courtney Clements
Mike Daniels
Ralph DeMarco
Marie Djordjevich
Jim Dunwoody
Jack Eitelgeorge
George Fiori
Wilma Flohr
Ed Fratini
Dennis Fujita
Audrey Herman
Trudy Hickey
Holly Hoods
Tom Kasovich
Karen Kasovich
Karl Kortum
Lucy Kortum
Harry Lapham
Marie Laskelle
Gaye LeBaron
Evelyn Lieberman
Bernard G. Lieder

Ed Mannion
Vonnie Matthews
Sam Miyano
Stan Mohar
Jim Myers
Shirley M. Oertel
Keio Okazaki
Ray Owen
Ross Parkerson
Dora Plaice
Carroll Reiners
Phyllis Schmitt
John Schubert
Chris Smith
Mae Smith
Noel C. Stevenson
Mary Testorelli
Althea Torliatt
Charles Torliatt Jr.
Ryo Torliatt
Clara Vandergrift
Valerie Vartnaw
Chandler Verity
Nicholas Verity
John Volpi
Sylvia Volpi
Stewart Wade

INTRODUCTION

Gold was the glitter that attracted the grizzled 49ers who risked life and limb to make the perilous trip across the continent to strike it rich. After gold, what? How did people live their lives? Where did they go and what did they do? The stories in this book give a sense of how people moved ahead with their lives after the gold bug lost its glow. The focus is a stretch of coastal and near-coastal farmland just north of San

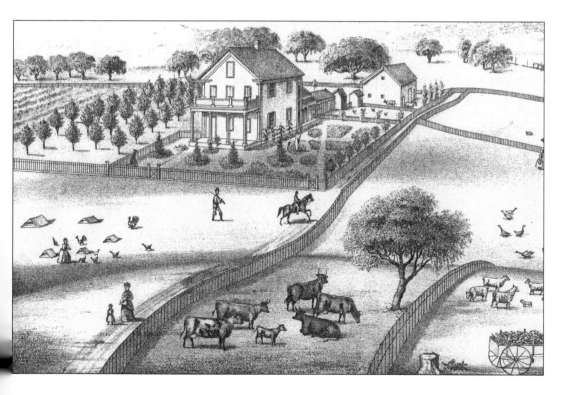

When the chickens flew into an oak tree in Penngrove, David Wharff decided that he, his family, and his birds had found a home right where they were. He left the town briefly, and then returned to work a 160-acre spread until he retired with family members in San Francisco (see story on p. 18). (Thompson 1887 Atlas of Sonoma County.)

Francisco's boomtown. Our stories will cover the 100 years from the Gold Rush until shortly after the end of World War II.

Golden Memories does not provide a sweeping view of the Redwood Empire from the mid-19th to mid-20th century. Nor is it a traditional historic look at community leaders. It is not about people who ran their towns but about people who kept their towns running. Instead of politicians, bankers, or timber barons, the book features people who rarely made headlines but who did the day-to-day work that kept their communities vital and alive. The stories are drawn from personal observations, interviews with family and friends, and accounts left by early settlers in the area. Today the redwoods still cast a giant shadow over this "empire" but the area is also becoming a center for the new "Gold Rush" of high-tech companies and fine-wine production.

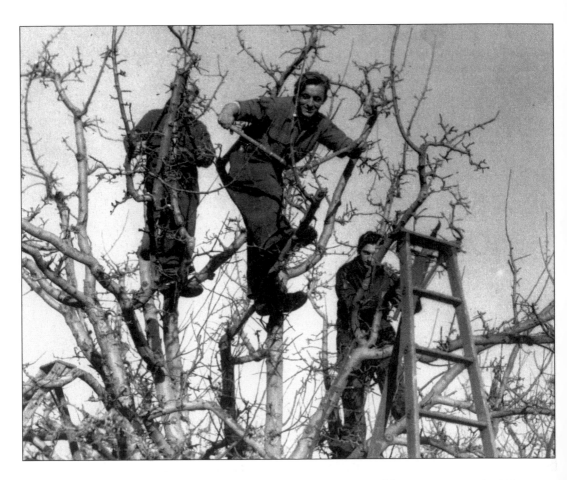

The world came to relatively isolated Sonoma County in World War II. Not only did young Americans go off to fight the war, but enemy soldiers came to Sonoma County. German prisoners of war—some from submarines and some from Rommel's Africa Corps—were incarcerated in the small community of Windsor north of Santa Rosa during the war. Three German prisoners, freed from the perils of combat duty, found new hazards as they learned tree-climbing and pruning techniques from local farmers (see p. 104). *(Steve Lehmann.)*

CHAPTER 1

Moving West

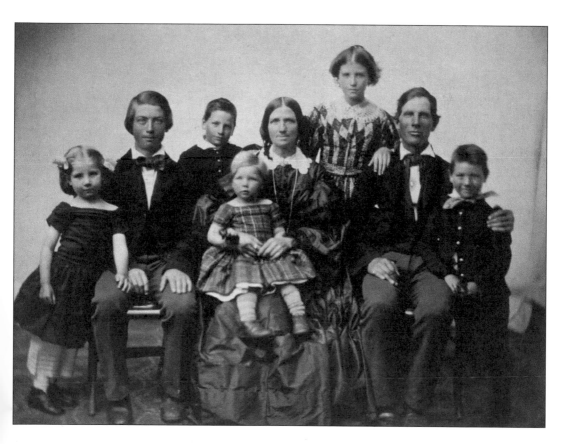

The Abraham Ward family, escaping the poverty of England's Fen country, followed the gold trail to California in the early 1850s. During a perilous two-year journey, one child died and another was born six weeks later. A copy of a daguerreotype, taken in the mid-1860s, shows, from left: Ann and James A. Ward, either John H. or Abraham Ward Jr., Naomi Ward with Mina on her lap, Hannah Ward Stewart Smith, Abraham Ward Sr., and either John H. or Abraham Jr. (Torliatt Family Collection.)

People from many parts of the world, mostly Caucasian, came to find a better life in the Redwood Empire. The 1879 Great Register of Voters for Sonoma County showed 5,774 voters, of whom 1,500 were naturalized foreigners. Leading the way was Ireland, trailed by Germany, England, Scotland, France, and Italy.

My ancestors, the Wards, came from the lowlands of northeast England, an area often dominated by raging floodwaters, grinding poverty, and heavy doses of superstition. Abraham Ward was born May 10, 1817, in Southery. All eight Ward brothers made their way to the United States, most to stay permanently. Abraham, after working on the west coast as a ship's carpenter in the late

After Abraham Ward enjoyed "good and bad luck" at Rough and Ready in the Gold Country, the family settled down on a 900-acre dairy ranch on the border of Sonoma and Marin Counties. (Torliatt Family Collection.)

1830s, returned to the fenlands one more time, to marry a neighbor, Naomi Porter, in 1840. Together, they packed off to America, settling first in St. Louis, where Abraham built ships. In 1850, the Wards struck out for California in search of gold. Shortly before her death, Hannah Ward, born in 1845, dictated the story of her family's perilous two-year journey to California.

HANNAH WARD STEWART SMITH

"My father Abraham Ward and his wife and three children, with my uncle and his family, along with 19 other families left St. Louis early in 1850. The 20 odd wagons with their oxen teams started out, but it wasn't long before 15 of them turned back.

"We had plenty of provisions and felt comparatively safe. Then my three-year-old brother contracted a severe illness and passed away. He was wrapped in a blanket, put in a small trunk, and buried in the desert. Six weeks later, at Deer Creek [near Caspar, Wyoming] a little boy was born to my mother and that night we struck camp in a rattlesnake nest. The stock stampeded and we had a terrible time. Finally, we arrived at a station where teamsters put up on their trips across the country. My mother wasn't feeling well, so my father rented a little hut for $100 a month. Roasting corn was one of the children's greatest enjoyments, and it was while I was doing this that my dress caught fire and I was badly burned. For six weeks my life hung in the balance, but my youth was a great asset, and, slowly but surely, I recovered. Then my father came down with a terrible fever and he was in bed for three months . . .

" . . . One morning we awoke to find all of our stock gone with the exception of two horses. My father and a friend left to look for them. They came upon an Indian corral and there they recognized their oxen. They drove them to our camp but the Indians followed us for two days and two nights. No one dared get out of the wagons and we feared that they would attack us at any moment. The men gave

them all the food they could spare and on the second night the Indian chief came to my father and patted him on the shoulder and said in his dialect, 'Heap brave chief, heap brave chief. Bye, bye.' And that was the last we saw of that tribe. Soon after, we arrived at Indian Springs [north of Las Vegas, Nevada.] where Mother leased a hotel and boarded the teamsters.

"The Indians' burial ground adjoined the barn of the hotel and their burial ceremony was particularly fascinating to us. They built a large fire and laid the corpse on top and the spirit of the deceased went to the Happy Hunting Grounds to the doleful sounds of the hired mourners and the beating of the tom-toms.

"One evening the chief of the tribe demanded that my mother exchange me for one of his sons. My mother hid me behind some trunks and there I stayed all night. After living in Indian Springs for one year, we left for Sacramento where my aunt . . . was taken sick with colic and died, leaving three children, one a baby of two months. In the latter part of 1852, we reached Santa Rosa and six months later we moved to Petaluma where I have spent most of my life. I am the last of 11 children and feel that in my 86 years of life I have experienced a good deal of history that goes to make up the story of the Great West."

(Abraham Ward and his family prospered on a dairy ranch on 900 acres on the Marin-Sonoma County border.)

RUBY JEWELL CODDING HALL

John Smith of Missouri and his family came west on a wagon train in the 1840s. They suffered many hardships along the way and met up with the ill-fated Donner Party.

"They lived on buffalo meat and other game and sometimes when hunting was poor they lived pretty meagerly . . . They met up with the Donner Party and arrived with them at what is now Donner Lake, west of Truckee [CA] . . . "

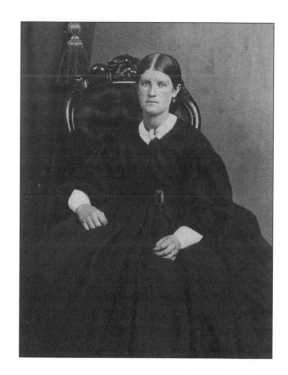

Her mother hid Hannah Ward Stewart Smith when an Indian chief sought to trade her for one of his sons during the trip to California. The last survivor of 11 children, she died in 1932. (Torliatt Family Collection.)

When leaders of the Donner group refused to move on quickly, John Smith, fearing the coming of winter, "separated his own wagon train . . . and started west over the mountains . . . Years later a member of the Donner Party . . . told my mother the last piece of human flesh she saw eaten was from a Negro, a stable boy who had starved to death.

"[The Smith people] were below the snow line just one day when the storms started that doomed the Donner Party . . . After three days and nights of snow, it was decided they must try to get relief to the Donner Party still east of the mountains. But the snow was too deep . . . John Smith led a rescue party back as far as they could go and somewhere near the summit they were forced to abandon their rescue mission."

11

Going back to Missouri, Smith sold his farms but never made it back to California. He died of Rocky Mountain spotted tick fever on the Oregon Trail.

H.O. FERGUSON

The nine Fergusons, a father, mother, and seven children braved many hazards to find a home in northern Sonoma County. In 1849, they joined 41 other wagons and about 300 people for the trip from Nebraska. They found themselves battling hostile Indians, cholera and a deadly storm.

"[We made] the first hundred miles in a very short time . . . but hidden danger was just ahead . . . [Indians tried to] stampede

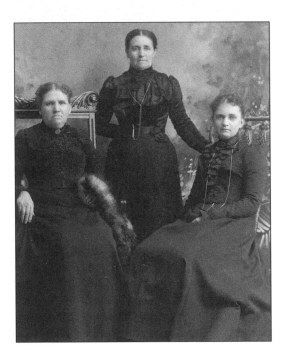

Ferguson sisters Elizabeth and Martha, left and center, were nine and three when the family left Nebraska in 1849. In spite of attacks by Indians, cholera scares, and a deadly storm, they survived to grow up and prosper in Healdsburg. Dora, right, was born in California. (Darla Budworth Collection.)

our cattle—perhaps wrapped in buffalo skins and coming up on all fours like a bear . . . they succeeded in taking seven yoke of the best cattle . . .

"One day . . . our Capt. . . . saw a great monster Buffalo alone. So our valiant Captain thought to capture him . . . When in shooting distance, he dismounted and advanced a few steps toward him, then taking careful aim he fired. The monster fell, so thinking him dead he rushed on him without reloading his rifle, knife in hand, intending to cut his throat, when lo and behold, the monster was only stunned. Up he came making a bee-line for the Captain, who made a hasty race for his horse . . . He reloaded, and with steady aim he sent the bullet that finished him. So our Captain came out the conqueror of the Goliath of the herd.

"[Later] we had beautiful camping places, abounding with plenty of green feed and water for our stock . . . without warning, we were attacked by an awful scourge of cholera . . . a lady was taken late in the afternoon and was dead the next morning . . . we continued up the Great Platt River for hundreds of miles . . . the home of thousands of buffalo and many herds of Antelope, giving us plenty of nice fresh meat . . . [At the Big Sandy River] we again encountered the awful Asiatic Cholera, losing one of our men . . . we were all spared—the original nine—Father, Mother, and seven children have escaped any sickness . . .

"[In Lassen County near the headwaters of the Feather River] we struck camp very early, finding good food and securing plenty of fish in the river . . . brother John and I . . . went hunting down the river from the camp . . . we came upon a fresh camp where some wagons had stopped a day or so ago, and there near their camp was at least a dozen fresh Indian scalps. The blood was hardly dry on them . . . we ran to camp, gave the alarm, and in a short time we were up and going.

In November, almost seven months from the start, the Fergusons and their friends the Alfords camped south of Red Bluff at Bruffs Camp.

"The Alfords [already in camp] . . . had

killed three deer, and when we arrived they had cooked for us a nice venison supper which we much enjoyed."

Tragedy struck when a midnight storm blew down a giant black oak.

"The body of the tree falling across our tent, in which was four children, and the top of the tree falling on the Alford tent, killing the old man and his oldest son instantly and fatally injuring the younger son and their hired man . . . the great concussion and tent poles left three of our children badly hurt, but none fatally so . . . there was left of the Alfords, the old mother and two grown daughters, who were almost frantic, wailing and mourning . . . During the remainder of the night a heavy snow fell, making a white winding sheet that covered the dead bodies to a depth of 6 to 8 inches . . ."

Seeking a safe refuge, the Fergusons took one wagon into the Sacramento Valley, leaving H.O. (Henry) and his brother John for two weeks to protect the gear remaining in their other wagon. They soon ran short of food.

"We were compelled to eat woodpeckers, so we thought a soup made of their broth would be fine . . . we . . . proceeded to eat but in a very short time two boys were about as sick as they could possibly be . . . throwing up . . . and suffering awfully. [When the father returned] he came to us bringing a loaf of bread . . . which our dear mother had made from flour . . . which was old, lumpy, and wormy . . . It seemed to us the most precious morsel of bread we had ever tasted."

After a winter in Lassen County, the father "soon found plenty of work in the timber camps" and moved on to operate a boarding house in Marysville. Three of the boys found they could make big money fast by selling candy to prosperous prospectors.

"Us boys . . . peddled candy in those big gambling houses . . . we made more money selling candy to the miners who came down from the mining camps by the hundreds, spending their money like dirt. The gold was so plentiful and they were foolish enough to think there would be no end to it, so candy . . . sold at enormous prices."

H.O. Ferguson, age 11 in 1849, survived the trip west with his mother, father, and six brothers and sisters. At one point, he and his brother had to eat woodpeckers to survive. Ferguson became a prominent rancher and businessman in Healdsburg and wrote of the trip to California in 1917–18. The ranch stayed in the family until 1942. (Darla Budworth collection.)

The Fergusons settled in Healdsburg in 1857.

M.C. MEEKER

M.C. Meeker, born in New Jersey in 1841, came west, married Flavia Sayre in 1868, and fathered seven children. He told his life story "at the request of my friends, to encourage poor boys and young men."

" . . . I was 20 years old, and father chose me to accompany my sister to California as guardian, she loaning me the money [$200] to

pay my fare . . . Arriving in California in December 1861, I contracted to work for six months for the $200 and my board at carpentering, after which I received $60 per month and board. Work becoming slack, I started a shop in Tomales, Marin County, and work soon poured in, so that I employed from 5 to 15 carpenters till [sic] December 1864, when I had saved $3,400 and went back East to buy machinery to start a planing, sash, door, and moulding mill . . . In the spring of 1866 . . . my machinery arrived. I purchased an interest in some redwood timber and began the erection of a saw mill . . .

"The Eastern machinery was too light, constantly breaking under the ponderous

Family picture of the Meekers, top, from left: Effie Meeker, Melvin Cyrus (Boss) Meeker, wife Flavia, and Robert Meeker; (bottom) Melvin and Alexander H. (Bert) Meeker. (Sonoma County History Society.)

weight of California timber. Eighteen sixty-seven found me in debt over three thousand dollars, but during the summer I made some money, so that in the winter of 1867–68, I put in two old boilers and a larger engine, built half a mile of railroad tramway, and when I fired [it] up one of the boilers broke open and had to be replaced with another.

"The previous fall a lady friend of ours came from Rochester to visit my sister, Mrs. Palmer, of Valley Ford. I called to renew acquaintance, was charmed, and in due time edged up close to her on the sofa, and gently put my arm around her waist, and said I possessed a great fortune. She did not say, 'Oh, this is so sudden!' No, not much. She waited for me to say something more. I drew her closer to my bosom, inside of which something was beating like the breakers on the ocean beach. When she said she had not heard of my good luck, I told her that it was only this moment that I realized the fact, and that this great fortune was her own dear self. Now we've been married 37 years, and we still love each other dearly. In 1870 I built a very beautiful home and furnished it. When a fire destroyed it all, entailing a loss of some eight or nine thousand dollars, we domiciled in the barn for three years, until I was able to rebuild again.

"The Town of Occidental owes its foundation and name to me, I having laid out and built most all of the first buildings, the church first, the hotel next, then stores and cottages.

"In May 1898, I laid out Camp Meeker for summer homes. Since then two additions have been added to it, making now the largest summer outing resort on the Coast . . . I never expected to become rich in this world's goods, but God has prospered me in all my undertakings, until I own over 10,000 acres of land, large interests in mines, mills, houses, fruit, and cattle, etc. I don't mention this to brag of what I have, but to show how success has crowned my labors. I have always been among the foremost of men in all charitable and public enterprises. The opposition I have met in laying out new roads, all of which today are the main avenues of travel in western Sonoma County, and the formation of new School Districts, has only helped to bring out my true manhood, and stay with mine enemy until he became my friend or was subdued. I owe my success, not to my own strength, strong arm, or active brain, but to the Good Lord, who has given these things into my keeping."

G.W. DUTTON

The perils were still substantial when the G.W. Duttons took a train cross-country just before the connecting of east-west rail links at Promontory Point, Utah, on May 10, 1869. They had the luxury of being transported on a train, but their sick children, rain, and the uncompleted rail link made for a miserable trip. The Duttons settled in Tomales on the northern California coast and the family gained prominence in Sonoma County.

"At Chicago the crowd going west was so great that we could obtain no sleeping car . . . we held the children in our laps all night whilst they slept . . . At Wahsatch [Utah] the descent is so great that the track was laid zig-zag, with a switch at each angle. It took us half a day to run 30 miles, during which time one of the freight cars ran off the track. They told me that almost every other train runs a car off the track. Whilst descending this steep grade, a car loaded with railroad iron became detached from a train above us, and about 300-yards distant, coming down the track with such velocity as to pass partly through our hind car. This car contained baggage, and passengers smoking. No one was hurt . . .

"Reached Ogden [Utah] . . . and that same night ran to Corinne, 28 miles further, reaching this last place at 9 o'clock p.m. This place is on the north bank of Salt Lake and is constructed entirely of tents. Mud ankle deep. It had rained, sleeting, and snowing for a couple of days. The night before, at Wahsatch, we were up all night with one of the children sick with the croup. At Corinne we had to remain up because no place to lie down could

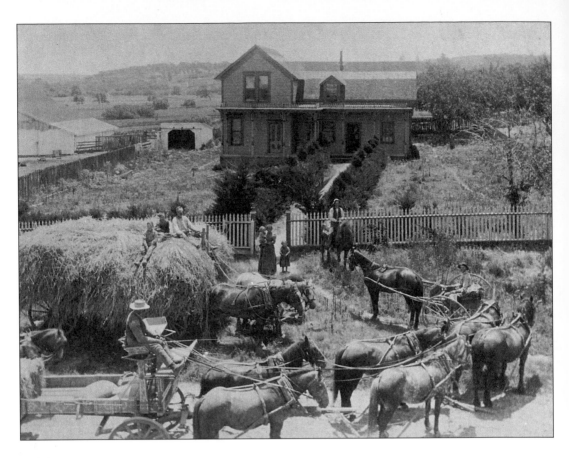

In the early days, many people toiled on farms such as the one operated by the McChristian family on Mill Station Road in west Sonoma County. Owen McChristian rests on the load of hay with Cecil and Pearl McChristian, William McChristian is on the horse, and Susan McChristian holds her daughter. (Sonoma County History Society collection.)

be obtained. Remained in the caboose car all night. It was with difficulty that we could get space enough to lay the children down. At Corinne we took the stage at 8:30 a.m., and reached, at dark, the place of getting aboard on the construction train to this end of the road. Distance staged about 65 miles. Distance yet to lay track, 30 miles, and 10 miles of this was laid the next day . . . No construction train being at hand we stopped over night in a tent with the ground floor perfectly saturated with water. I laid down three sacks of shelled corn, (all there was) and a piece of box to complete the rectangle. Spread a robe over this, laid down the three children, chucking them close together, and covered them over with two pairs of blankets. Myself and wife remained awake during the night, and kept up fire with green sage brush. This was the third night without sleep.

"The construction train came along next day . . . about 10 a.m. We had no place to sleep, and consequently went without on the following night, making the fourth night without sleep. At 3 o'clock the next day we reached Elko (Nevada) . . . Remained at Elko . . . to take the passenger train for Sacramento . . . "

CHAPTER 2

The Early Years

David Wharff, one of the earliest white settlers in Penngrove, tried potatoes but found that he did a lot better raising chickens.

Wharff returned to Boston to wed Olive Densmore, a marriage that lasted more than 61 years until her death in 1913. The Wharffs had seven children.

The newcomers in California came looking for gold but many eventually retreated to a steadier style of life. Numerous of those looking for a permanent home where they could raise their families and plant their crops turned to fertile areas like Sonoma County. Here's how things looked in 1886.

"It is the second [county] on the coast, north of, and distant 30 miles from San Francisco; having a frontage of 18 miles on San Pablo Bay and 60 miles on the Pacific Ocean . . . It embraces about 1,000,000 acres of land, of which about 400,000 acres consists of rich bottom land, 350,000 acres of lower foothill land, and the remainder composed of swamp, mountain, grazing, and redwood timber land.

"It has one good harbor [Bodega] . . . It is traversed by two railroads . . .

"The country bordering on the coast . . . early became famous for the abundance and quality of its potato crop, and now is equally noted for dairy products . . . the eastern slope of the coast range of hills [west of Santa Rosa] . . . is found to be exceedingly well suited to fruit and hop raising . . . The valleys of Petaluma, Santa Rosa, and Russian River . . . yield immense crops of wheat, corn, barley, and fruits of every kind . . . The grape is one of the standard crops of this county. The wine in 1886 amounts to 2 million gallons, and will probably be increased to 3 million gallons in 1887.

"Within [the county boundaries] are found the world-famous Geysers, and many other mineral springs, which possess wonderful curative properties . . .

"The county has a population of 30,000. Its principal towns are: Petaluma, with a population of 4,000, noted for its flourishing shipping business in grain, flour, fruit, potatoes, hay, dairy products, and poultry; Santa Rosa, the county seat, with 6,000 inhabitants, remarkable for the thrift and enterprise of its people, its public and private schools, seminaries and colleges, its fine public buildings; Healdsburg, population 2,000, is situated on Russian River, in a fine and prosperous section; and Cloverdale, picturesquely located at the terminus of the San Francisco and North Pacific Railroad, is the principal shipping point for the wool, hops, and other products of Mendocino County, population 1,000."

EARLY YEARS
THE 19TH CENTURY

It was better than living out of a wagon train, but life in the Redwood Empire in the early days was anything but a picnic. The shadow of disease and sudden death hung over the pioneers who carved out the history of the area. Still, most people persevered and fought to improve their lives and those of their children.

DAVID WHARFF

Which came first in Sonoma County—the chicken, the egg, or David Wharff?

If one believes pioneer rancher David Wharff, he and the chickens arrived in Sonoma County together. When Wharff and his family found a home in Penngrove in 1852, they brought a flock of chickens with them. When he died in 1918, Wharff was credited with being the first person to raise poultry and market it for profit in what came to be known as the World's Egg Basket.

Wharff, born in Gloucester, Massachusetts, in 1828, came from a famous New England colonial family. Lured west by gold, he arrived in San Francisco in 1849. He mined and worked as a carpenter. In 1851, he went back east and married Olive Densmore, returning to San Francisco in 1852.

His life changed when he got a tip from a fellow migrant. The man, looking for a place to plant a bundle of fruit trees, urged Wharff to take a 50-mile sailboat ride up "a very crooked river" to Sonoma County.

Wharff, in memoirs written shortly before his death in 1918, said:

"The man took me out to see the land I was to have. I liked the looks of it . . . Stayed

at the man's tent two days, helped him lay his floor and put up the frame of his tent, then I went back to San Francisco. Told my wife what a fine ranch I had."

Then came the moment that would ultimately lead to Petaluma claiming its place as the Egg Basket of the World. Wharff "went out to the Presidio [in San Francisco] and bought 6-dozen laying hens . . . "

Wharff said he landed in Petaluma with a wagon and team, and all his worldly possessions in the wagon, including a wife and baby.

"When we left Petaluma [for Penngrove, a few miles north] my wife, Olive, inquired where we were going. 'Going home,' I answered.

"When we got near Penngrove, an accident happened. We had a coop of chickens fastened upon the back end of the wagon . . . we paid $37.50 a dozen for them. The coop fell off and the chickens all got out, most of them flying up into an oak tree. When my wife asked me what I was going to do about it, I said, 'Well, the chickens seem to like the place and so do I, we are hunting for a home and I think we've found it. How do you like it?' She said it was fine. We got out our wall tent, pitched it, and moved in."

They lived out of the tent for a year, and then moved into a more permanent home.

"My first farming was potatoes. I calculated to make a fortune raising potatoes. I heard of a man over at Tomales that had seed potatoes for sale. Would sell for $12 a hundred. He said he had two ton and would sell them for $200 a ton. Four hundred dollars for the two ton. I told him I would take them and gave him two $50 slugs as a deposit. I went with a team and brought them over . . . the ground was fine. They came up and looked fine and I thought I would make a big thing on potatoes and chickens—eggs $1 and a half a dozen. There was plenty of deer as well as other animals. It got along to the third day of September 1853—at noon I smelt smoke. Could see no fire though. Went up back to see where it was. Only went a short distance and could

see it coming. Told my wife to go in the Potatoe [sic] patch with the baby.

"There was no danger for I had a crop of barley near the tent and the hens had scratched the ground so there was nothing to burn so that saved my tent. That night at eight o'clock the fire was over the Sonoma Mountains, no roads to stop it. All wild oats as high as my head. The fire would get in the dead branches of the trees and after dark it looked like a city.

"You would ask how it started. There was a man that lived back of me that had 50 acres of potatoes in and Tom Hopper's cows used to come over and eat the tops off so he burnt the grass off to stop them . . .

"[In the fall] the potatoes were beginning to turn, so the first of October I began to dig. I went down to Petaluma and bought sacks for which I paid $16 a hundred. Got the Indians to help me dig. Had a fine crop, many of them would weigh five pounds each. All new land, never been turned before. After they were all dug had a man haul them to Petaluma; put them in Harris' Warehouse at $10 a ton for the season. So far, so good. The first of February I wanted to sell them. I asked Mr. Harris about the market. He said he had been to the city and could not sell them but to wait. Went down again, he had heard from the city—no market for potatoes. Market full, worth hardly nothing and they were beginning to sprout. He said he would like to have me move them. I told them if he wanted them moved he would have to do it himself for I would not touch them. He dumped them in the creek, sacks and all. So you see what a good thing my potato crop was . . . So I was sick of raising potatoes . . . "

The Wharffs sold their ranch and furniture for $200, moved to San Francisco, and then returned to Penngrove to buy a 160-acre ranch.

"I went back to the city the next day [and] told my partner what I had done. He knew of a man by name of Bishop who had a number of young heifers he wanted to sell. Said he lived out beyond the Mission. I think it was

where the Cemeteries are now. I started in the morning, walked out there and back in a day. I bought 12 head for which I paid $40 per head. His man helped me to drive them as far as the Mission Church.

" . . . When I got up the next morning early, they were gone. My partner told me to go around to all the slaughter houses and see if the floor was wet and if it was they had been butchered. I went to four but the floors were dry. Then he said they had gone home, so I started to see. Got over to Bishop; he went out to see if they had come back. He found them all lying down. We got some dinner then he helped get them off the Range and they went along all right this time. This was in 1854 . . . Next morning got them aboard the steamer for Petaluma, then drove them out to the ranch. There was a little field [a fine field] and they did well there. There was plenty of range for them to run."

When he died in 1918, Wharff was the oldest living subscriber to the Petaluma *Argus* newspaper. He acted as an unofficial correspondent, reporting on the lives of his fellow ranchers, including the most isolated family in the Sonoma Mountains. In 1883, Wharff wrote, "My wife and I go up there every year . . . we have made an annual visit to a couple of dear old friends . . . Adrian Warrington and his wife, the former 73 years old and the latter 72, both hale and hearty— in fact they do not know what sickness is— settled on the mountain early in the '50s. They have a magnificent farm of 420 acres— well improved and well stocked—and are surrounded with all the comforts that wealth and good taste could provide. From a point near their residence, the city of Petaluma is in plain view—distant only 12 miles—the broad valley, the low hills, the fine vineyards, orchards, and fields of waving grain, present a picture of such beauty as one seldom sees. Thousands and thousands of acres of highly cultivated and the most productive lands in this state are spread out before you . . . In sight of all this, the good old couple reside. Mr. Warrington visits Santa Rosa to pay his taxes annually, and occasionally comes to Petaluma for the mail and such supplies as they wish from the stores. Mrs. Warrington has never yet been to the county seat, and has not been in Petaluma since the year 1856. She has not been off the farm for many years, and has no desire to go. This place is by no means a 'hermitage,' for although they have no children, their latch string is always out and they entertain many of their friends in the most hospitable and kindly manner. There is no romance in this story, it is made up of plain facts."

When she died in 1886, Wharff marveled that Mrs. Warrington "has never seen a railroad."

SAREPTA TURNER ROSS

M rs. Ross, born in 1848 in Missouri, came west in a wagon train with her parents, settling in rural Sebastopol in 1854. She wrote her recollections in 1914.

"There were no stores in Sebastopol when I came here, and the place had not even a name . . . The first time I came through Sebastopol I was with my mother and brother going to Green Valley to visit my uncle . . . In those days we had to go on horseback. My brother was riding a mule and I was riding behind him. I was so afraid of falling off that I hung on with both hands with all the grip I had. We had 10 miles to go, so by the time I got there my hands were so cramped that I could scarcely open them.

"We did not have saw mills to make lumber for building our houses, so the men had to go into the redwoods and hew out all of the lumber. They would split 'clapboards' for the outside of the houses, then take a plane or drawing knife and plane them off. There were no planing mills. Jasper O'Farrell owned O'Farrell hill where there was a large body of redwood timber. He sold the trees standing. The farmers bought them, chopped them down and worked them into pickets, rails, and posts to fence their land.

"The first flour mill in this county was run by Mr. Calder. It was just a little way from

where our apple show is held, and on the same stream. It was run by water power, and he had no screens to take the seeds out, so everything was ground up together, wheat, seeds and all, and I tell you it was very poor flour, but he made good corn meal.

"When I was a child, people did their cooking in the fireplaces. They had an iron rod across the fire place, and chains with hooks at the ends hanging from the rod. These were to hang the kettles on. Then they had what they called Dutch ovens. In these they baked bread, pies, cakes, etc.

"The first time that I ever saw anyone making wine was in our smokehouse. We all raised our own meat in those days, and cured it in our own smokehouses . . . we had some Italians burning coal on our place and we also had grapes. They bought some grapes and a large barrel. On Sunday I went in the smokehouse to get some meat for dinner, and lo and behold, there was an Italian in there. He had taken off his boots and was in the barrel tramping grapes. My husband had been at their cabin a few days earlier and had tasted their wine, and had been telling me how good it was.

"The first bridge we had across the Laguna . . . was a place where there were no channels, and the water spread out for quite a long distance, so they just hauled in logs until they could cross over without getting stuck in the mud. It was called the 'squatter's bridge.' I do not think our friends would enjoy a ride over it in their autos. It was hard enough work to stay in the wagon with the team drawing us.

"Mr. Easly's used to be a great resort for young people on Sundays. They would go there to eat strawberries and cream and the young men would buy bouquets for their best girls and pay from 50¢ to $2 for them."

MAE SMITH ON THE MERRITT FAMILY

John Merritt and wife Mary, natives of Ireland, had 12 children, 7 of whom survived to adulthood. The Merritt family started across the plains in 1852 with an ox team when one child was six weeks old. The trip took six months and ended for a time in the Sierra, where John Merritt tried his luck at mining. In 1858, they were in Wyandotte.

"While her husband was working in the mines, Mary [Mulligan] Merritt cooked for other miners. While they ate, the miners left their bags of gold or 'poke' on the table, where little bits leaked out of the sack and stuck in the cracks of the table. When the men finished their meals, Mary dug into the cracks, dug out the powder and built a big poke for herself."

Mary Mulligan Merritt cooked for miners and made money digging gold out of the cracks in tables; her husband John later opened a fine saloon in Petaluma. Their luck changed when, in 1886–1887, sisters Emma and Katie Merritt (above) were stricken with typhoid fever. The girls, aged 19 and 16, died within 2 months of each other. (Merritt Family Collection.)

POLLY LARKIN

In the 1880s, Merritt opened the American Saloon in downtown Petaluma. It was described as "the finest place of its kind in Petaluma."

Less than three years after the saloon opened, tragedy struck. Two daughters of the Merritts fell victim to typhoid fever. Emma Merritt, 19, passed away in November 1886, and Katie Merritt, 16, died in January 1887. Writer Polly Larkin looked back at the family's loss of two cherished daughters in less than two months:

"Miss Katie Merritt, the youngest and only unmarried daughter, fell asleep to waken in a brighter world. In life the sisters were devoted to each other and 'in death they were not divided.' The young ladies were favorites of all who knew them. Miss Katie was buried from the Catholic Church last Sunday afternoon and laid to her long rest beside her sister in the Catholic Cemetery."

The residence at 101 Bassett St., a one-story Queen Anne Cottage, is now one of the historic houses of Petaluma.

AUNT JENNIE (MRS. GEORGE S. CRANE)

"I met Grandmother and Grandfather's family in 1875. At that time there were nine children at home [near Penngrove] . . . in the 48 years they lived on the ranch, I don't think [grandmother] ever bought one loaf of bread or bought one box of soap. They had a large iron kettle that held 50 gallons or more. She cooked out the fat from the hogs for making the lard for shortening, then she used the cracklings for making soap. I remember the ash hopper where she put the ashes for making soap.

"She said the first bed she had was a slip made and filled with straw. She used this for five years—until she raised geese and made a feather bed [the straw was put in fresh each year after the thrashing was done]. Grandmother made pillows and feather beds

for all her children and quilts for all of them. You seldom ever saw her hands idle. Everything was done systematically, breakfast 6, dinner 12, supper 6 . . . [After I was married] we had the big families— sometimes 18 for breakfast, and weekends when company came there would be 21 for meals, with biscuits, fried ham, eggs, honey, syrup, for breakfast, and pear and peach preserves for Sunday morning. The homemade sausage was wonderful. They usually made 50 to 75 pounds, then put it in little home made sacks about 18-inches long, 5 or 6-inches around, then smoked it. Grandfather would have dozens of hams and shoulders hanging to be smoked. He used some special wood to smoke with, but I have forgot the name of it. Grandfather always got a blue ribbon at the . . . fair.

"Grandmother did lots of sewing. I remember helping her make work shirts and the men's drawers . . . Grandmother said when she first came to the ranch, it took them a whole day in winter to go to Petaluma to do a little shopping [no paved roads in those days.]

"One thing we did enjoy [was] going in the parlor and singing. Aunt Hettie played the organ very nicely, Uncle Charles singing bass, Father tenor, and the rest singing whatever we could. [Grandmother in the living room] mending and doing socks. She made the candles they used. I remember seeing her pouring the tallow in the molds. They used kerosene lamps in the living room and kitchen."

JAMES O'PHELAN AND N. CRILLY

In the early days in the Sonoma Mountains, disputes were often settled informally, if not peacefully. A boundary dispute came to a violent head in May 1872, pitting an irate mountain woman against an overmatched Irishman. The newspaper report:

"There was considerable excitement created on the Sonoma Mountains one day last week, growing out of a dispute on boundaries of the lands of James O'Phelan and N. Crilly. Crilly, it

seems, ran a fence through the premises of the neighbor O'Phelan, who, after taking counsel in the matter, determined to tear the same down. He was in the act of removing the fence, being assisted by a hired man, when Mrs. Crilly appeared from a buck-eye bush, and with a handful of rocks and the 'sprig of shelalah,' commenced a vigorous warfare. One rock struck the hired man on the head, inflicting an ugly scalp wound, which rendered him hors de combat. She then directed her attack against O'Phelan, and administered a severe blow upon his 'cronk' with her stick. This let him out and left the woman in possession of the field. A warrant was sworn out for her arrest, and Deputy Sheriff Hedges was two days scouring the hills in search of the combative Amazon. It appears that after her splendid feat at arms she became frightened and took to the brush, and up to date the place of her retreat remains a mystery."

LOUIS FOPPIANO

Friends or relatives often provided the impetus for immigrants to move to America, as in the case of the Foppianos.

"My grandfather John Foppiano came in 1864. He was from . . . 40-miles south of Genoa. He walked across the Isthmus of Panama and then came up [to California] . . . he was in Sonora for two years, and then he came to Healdsburg. He had some relation over here . . . They started a vegetable garden here in Healdsburg. He worked in the garden and sold vegetables with a horse and wagon; he'd go to Santa Rosa . . . he made a few dollars, and then he started buying ranches. He bought a couple of ranches. He bought the ranch where the [Foppiano] winery is in 1896."

EARLY YEARS
THE 20TH CENTURY

It's not clear whether Peter Torliatt Sr., a teenager living on the French-Italian border,

left home because he wanted to avoid service in the military or because he was accused of throwing a rock at a Catholic priest in his village. It depends whether one believes the story told by his daughter Theresa, born in 1890, or his son Peter Jr., born in 1897. Whatever the reason for his quick exit, Peter Sr. made his way to the Sonoma Mountains above Penngrove where his prize berries earned him the title of Strawberry King.

PETER TORLIATT JR.

"My father [and] . . . Louis Marion became partners on a ranch near Penngrove. The family liked to tell the story of how my father and mother got together. Marion sent money to Paris so that his sister Pauline could come over and work on the ranch. Instead, his sister Adrienne got a hold of the money, bought a ticket and showed up on his doorstep. When the story came up, mama always denied that she stole the tickets. She married my dad [in 1888] and they set up their own ranch.

"Having kids was just part of a normal day's work . . . the midwife would come in and that would be it. My mother had Marie [born in 1889] in the morning at the ranch and she was out milking cows in the afternoon.

"Life was all right on the ranch. We were located damn near on top of the mountain. We had a small dairy. There were tomatoes, corn, chickens, and my father finally went into strawberries. My father would kill a pig or lamb—we had our own meat mostly. Lots of things were salted, [since] we didn't have any ice. Only the rich had that. We used to go out and shoot chickens and rabbits. The first time I ever shot a shotgun, I aimed at a rabbit in the field. I had a double charge of powder; I missed the rabbit but the recoil blew me back into a big trough of water.

"My parents sold milk and cream locally to the creamery and sent some of it on the boat to San Francisco. We kids were absolutely

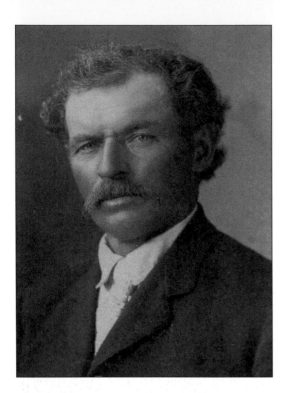

Peter Torliatt Sr. apparently had to make a quick exit from his village on the French-Italian border when he was caught throwing rocks at a priest. He came to the Sonoma Mountains south of Santa Rosa and became the strawberry king of Sonoma County. (Torliatt Family Collection.)

buy as many as you wanted. My father salted them down. The watermelon boats could get as far as the Haystacks [south of Petaluma]. A man would come ashore, take a rope and pull the schooner up by the Washington Street Bridge. Later, tugboats came in and tugged the boats up the river.

"Dad had a vineyard. He and old man Elmore got in there and drank it. How they drank that stuff I'll never know. It was more vinegar than wine. They drank wine all the time, very little whiskey.

"After my father and mother separated [they filed for divorce five different times but never divorced although they did finally separate], the old man moved to a ranch on Ely Road [east of Petaluma]. I was thrilled. We had 30 acres and a 2-story house. I helped build the house . . . even though I was just a little guy, I remember packing boards from the driveway to the front of the house . . . I was pretty proud of myself.

"[From the new ranch] it took the old man 45 minutes to get to town but once he got some money in his pockets, he got a terrible thirst. Sometimes it took him two days to get home.

"After they separated, my mother and father met once on the street. She said, 'Hello, you G— D—- Dago.' He answered, 'Hello, you G— D—- Frog.' They didn't get along too well."

THERESA TORLIATT JEWETT

"I only weighed 1 pound, 14 ounces when I was born and my parents were afraid I wouldn't make it. Grandma Watts was the midwife who lived down the road. She came in and put me in a shoe box lined with cotton. To keep me warm, she put me in the oven. When it was time to do the daily baking, they took me out and gave me to someone to hold. I was never seen by a doctor [Theresa died at age 96].

"When we were on the Hopper ranch, my father's brother came from France. When the doctor from Petaluma came out to check on

forbidden to go into the butter house. My mother and father had pans and had to skim cream off the top of the pans. They used to think there was a little rat eating the cream but the rat was little Peter [me] . . . I'd take the cream, put in some sugar and it was just like ice cream. Then I'd toss in strawberries. I was in heaven.

"I was afraid of my father. He told me if I was a bad boy, he'd give me two fingers in the mouth. Most of the time, he gave me five in the mush.

"A lot of food came in on the Petaluma River. The fish boat came up to the Washington Street Bridge [in Petaluma] and they would sell herring. They'd dock, take buckets full of fish onto shore, and you could

the family, he told Peter that this man, whoever he was, [was sick and] should not be allowed to stay. He told Peter to buy him a ticket and send him back to France. Peter did this and two months after the brother returned to France he died of tuberculosis. There is quite a history of tuberculosis in Peter's family. His three sisters died before they were 21 . . . However, his mother lived to 103.

"I remember going down to San Francisco with my father. We went on the train to Tiburon and then we took a 'floating house' [ferry] to the San Francisco Ferry Building. There were no sidewalks in San Francisco along the Ferry Building, it was all a boardwalk.

"[During one economic depression] I remember all of my father's butter and eggs were shipped home because they couldn't be sold. My father told [the dealer] to give them to poor people and not send them back again. They melted the butter and fed it to the pigs. At that time, butter was 10¢ a pound and eggs 8¢ a dozen.

"Adrienne and Peter [Theresa's mother and father] fought a lot. Peter came home drunk one day and he and Adrienne had a really good fight. Well, the children had an old scrub cow named Billy. They could milk the cow from both sides. They would ride the cow and she was quite a pet. After Peter left the house he decided he was going to milk Billy, who quivered every time Peter came near. When he tried to milk her, she bolted and ran right through the tin milk shed . . .

"I was more afraid of my mother than my father. I remember spilling the cream so I ran off and hid under the dairy. I stayed and slept there all night with my head on the dog. Everyone was looking for me. A hired man dropped a bucket the next morning and this startled me awake.

"A lady was living with Peter [Sr.] just before he died [in 1916.] Peter deeded her 5 acres. She moved to Sonoma with her child. I think the child was my dad's. My mother [long separated from Peter] met her uptown one day and beat her up at the train depot.

"On the Hopper Ranch [in the Sonoma Mountains], there were 1,000 acres. In September, the rich Frenchmen from San Francisco came up. There was a spring [on the ranch], in fact many springs. They would go to these springs and get a bucket full of frogs [considered a delicacy by many Frenchmen.] They would chop the frogs in half. The heads would fall in a bucket while they were still croaking. The children used to cry so hard Peter made them stop."

"In September, Peter got out the big

Theresa Torliatt Jewett weighed less than 2 pounds when she was born but lived to age 96. She spent her early days in a shoebox and was placed in an oven to stay warm. Later, she toughened up doing daily chores on her parents' ranch in the Sonoma Mountains. Farm life included annual trips to work in the hop fields of Sonoma County. ((Torliatt Family Collection.)

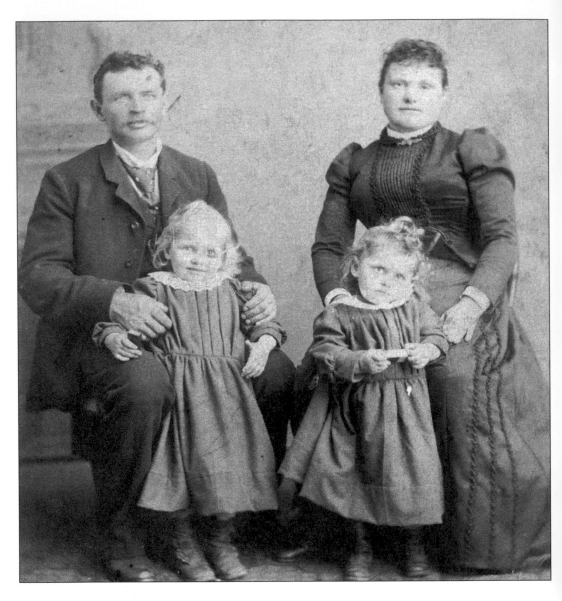

Peter Torliatt Sr. and his wife Adrienne, with daughters Marie and Theresa in 1890s, lived a less-than-harmonious life in the Sonoma Mountains near Penngrove. Between them, they filed for divorce five times and were called into court when Peter Sr. was accused of shooting at neighbors during a family dispute. Torliatt told the judge he had been shooting at an owl. (Torliatt Family Collection.)

springboard wagon and took my mother and the rest of us to the hop fields for two and a half or three weeks. We would leave her and the smaller kids in a tent and start picking. It was terribly hard work under a hot, hot sun. If you got a hop scratch, it left a terrible brown mark. I got up at daylight and started to pick. They weighed the hops at noon and again at 4:30. Then we had supper and I fell in bed exhausted. When I was lucky I got to stay out of the sun and babysit my little brother Adolph.

"They would go to Santa Rosa during the strawberry season to get the Chinese to help [at the Hopper Ranch.] They slept in a house 1 mile from the house where we lived. They would take care of the strawberries, even selling them in Santa Rosa. They would go with two horses and a wagon. There was a canvas over the strawberries so they wouldn't get dusty. Once when they cheated my father, he took a bolt out of the wheel [of the wagon] and when it went around the corner the wagon fell over and all the strawberries fell out. The Chinese had him arrested for hitting them."

Although "a simple man of the hills," the senior Torliatt appeared in court numerous times. His most celebrated case involved an incident on the ranch Feb. 1, 1899, in which he claimed he shot at an owl to protect his farm animals. A couple of neighbors claimed the shots were aimed at them. The incident started when two Torliatt children, Theresa and Charlie, ran down the road to the home of David Horne. They told him that Peter had been breaking dishes and planned to do similar damage to their mother.

VERNE MOLLER ON LIFE AT THE HICKEY RANCH

John Hickey, born in Ireland in 1806, started farming in Maine in the 1830s. Seeing few prospects for success in the small farm and lumber town of Whitefield, his three boys, Maurice, John, and William, all moved west. Maurice and William came to California and John became a miner in Montana.

Maurice migrated to Petaluma in the 1860s. William worked as a lumberman on the North Coast of California before returning to Maine. At one point, probably in the 1880s, the three brothers reunited in Petaluma for a formal portrait.

Maurice Hickey and his wife Mary raised eight children on a 30-acre poultry ranch just west of town. Their grandson Verne Moller, born shortly after the earthquake in 1906,

lived in San Francisco but spent his summers on the Hickey ranch.

"When I was a kid, coming to the Hickey ranch was the great joy of my life. I remember lots of hay, cows, and chickens. They sold eggs, milk, and cream in town. Grandma and Grandpa [Maurice and Mary Hickey] both milked the cows, and they taught me how to do it, too. After the folks bought a separator for the milk, they took only the rich cream to sell in town each Saturday. We mixed the residue from the milk into the chicken mash and pig's feed. They had a kale patch with a picket fence 6-feet high, which was supposed to keep out

Father Kiely, born in Ireland, was the longtime pastor of St. Vincent's Catholic Church in Petaluma. Praised for the ability to raise funds for his parish, he raised the ire of young Verne Moller the day he took home two buckets of freshly scrubbed eggs from the Hickey ranch. (Petaluma Library History Room.)

27

intruders. From time to time, we sent the chickens into the kale patch to eat. When the leaves were gone, we pulled up the stalks and fed them to the livestock.

"Mother Hickey was a devout Catholic. Father [James] Kiely [the Catholic pastor] used to come to the ranch. One day . . . before he left he asked Grandma for some eggs. Being a good, God-fearing woman, she told him to take what he wanted. Before I could get them out of the way, he scooped up two buckets of eggs that I had spent the whole morning cleaning [sandpaper was used to get the chicken droppings off the eggs.] He took off down the road with my beautiful clean eggs. I was ready to cry. I got

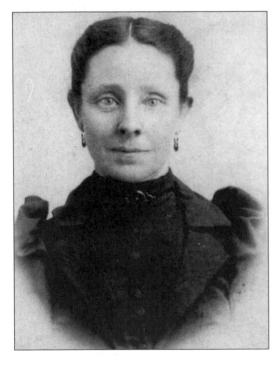

Mary Merritt Hickey, born in St. Louis in 1852, started the wagon trip west with her family when she was only five weeks old. She married Maurice Hickey in 1870 and became the mother of eight children. Even though she had a big family, she was always willing to share food from the ranch with her pastor, Father James Kiely. (Torliatt Family Collection.)

left with two more buckets of dirty eggs to clean.

"I had to keep an eye on my cousin Sam Hickey, who was a couple of years younger than I was. He was a real fighter and was always getting into trouble with the other kids. One day, Sam got into it with several other guys, and he was getting knocked around so I decided I better stop the fight. I grabbed a horsewhip and yelled at the other kids to quit or else. Sam came up from the bottom of the pack, madder than hell. 'Why did you do that?' he asked me. 'I was having fun.'

"The Hickeys had a son named John. He made his living as a horse trader. One summer, I watched him trade a blind horse. He told me a guy came up to him one day and he wanted to buy the horse. They made the sale. We all laughed for years after—the guy needed a second horse to lead the first one around.

"We all looked forward to Sunday. If the weather was good, a whole bunch of us piled onto two wagons for a ride to the ocean at Dillon's Beach. The horses pulled another wagon that carried the food. We started early in the morning and got back late at night.

"And then there was the big fire. I was at the Seeley place across the road with Sam Hickey when the fire started. I think I was seven and he was five. I grabbed Sam's hand and held him tight. We tried to get the attention of the firefighters to let grandma know we were all right. The Petaluma firemen came to the city line but couldn't come out to fight the fire because it was not their territory. Volunteers from McNear and Vonsen feed companies came out with wet, empty burlap sacks and tree branches and whacked away at the flames. It was quite a sight.

"In the middle of it all, we heard a big explosion. In those days, they kept explosives on the ranches to bore wells or take out tree stumps. The fire burned the old blacksmith shop where they kept the dynamite, providing us with our own little fireworks show. Boards went flying everywhere. They told me later nobody got hurt."

The Hickey brothers struck out from Maine to seek their fortunes. Maurice Hickey (left) became a chicken rancher in Petaluma, brother John (right) was known as the "Rock Derrick" when he became a miner in southern Montana, and brother William (center) worked as a lumberman in Mendocino County before returning to Maine to start his own family at the age of 49. The brothers, far from home, met in Petaluma, probably in the 1880s. (Torliatt Family Collection.)

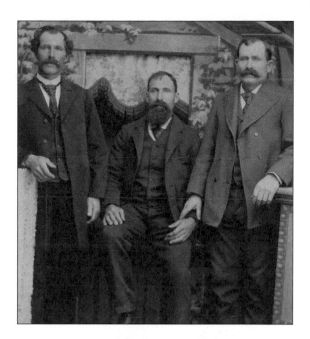

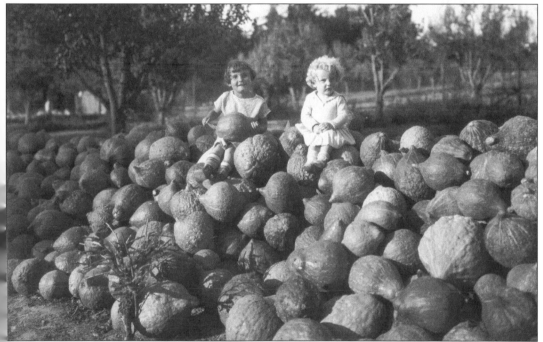

The fertile soil of Sonoma County attracted migrants from all over the world to settle down, grow their crops, and make a living. Farmers milked cows, raised chickens, and grew the vegetables they needed to carry them through the good and the lean years. As the Hickeys prospered on their 30-acre ranch just west of Petaluma, visiting relative Muriel Stewart (left) and a little friend turned a huge pile of winter squash into a children's playground c. 1927. (Torliatt Family Collection.)

George H. Ott

George H. Ott, pigeon fancier and retailer, came to Petaluma in 1901 when he was 17. He opened his stationery store at 139 Main St. in 1912. More embarrassing, he joined in a clandestine scheme to "clean the creek," a secret he kept for many years. Here is Ott's story:

"Here is a true story of the olden days . . . before the Petaluma Creek was dredged beyond the Washington Street Bridge and . . . widened from there to D Street.

"From the Washington Street Bridge north it was just a narrow creek about 10-feet deep, and when the tide came in it would go way up the creek nearly to Corona Road. When the tide was out the creek, all the way both ways, was dry as a bone.

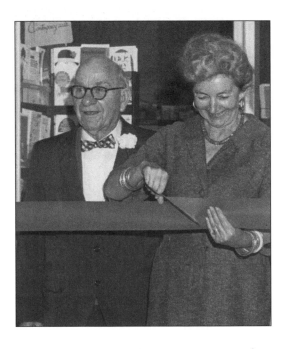

George Ott, prominent operator of a Petaluma stationary store, kept a secret for many years about the "mighty dam" he helped build on the Petaluma River. Years later, he took part in a ribbon cutting with Mayor Helen Putnam. (Petaluma Museum.)

"Oh, me—dead chickens, cats, dogs—oh, everything.

"An old carpenter whose name was Jim Melson [long-time dead] conceived the idea that if you would go up the creek back of Hunt and Behrens and the Poultry Producers [neither of which had been built at the time the gate scheme developed], then build in solid posts on each side of the creek, build a solid portable door or gate which could be swung open up the creek when the tide came in, then raise the door and let the tidewater go up the creek as far as it could go. At high tide, close the door and keep the tidewater above the gate until the tide was at its lowest. At that time, raise the gate and let the water loose [an estimated 2-million gallons of water].

"This was his idea.

"He and I were good friends, and he wanted me to back him: he would do all the work free, but I was to get him the lumber and the nails.

"'Jim,' I said, 'you are the biggest nut in Petaluma.' Finally I weakened and said, 'I'll try,' but he was to leave me out of it as it was 'Melson's Folly' as far as I was concerned.

"So what did I do? I went to my old friend John Camm of Camm & Hedges Lumber Company, and told him I wanted some lumber to do this job, and he asked me who would pay him. I said no one, but that I really thought Melson had a fine idea and I had promised him I'd help him.

"John looked at me and said, 'George, you are a big fool—but I'll help you. I'll give you the lumber.' Which he did.

"So Jim Melson went to work on it and finally the gate was finished. One night, after dark, we installed it. There were only three of us who saw it: Jim Melson, John Camm, and myself. John didn't want anyone to know that he was fool enough to get mixed up in a deal like this.

"When the tide came in full and high, we slid the door down into its place and it fitted o.k.—it surely did.

"We waited and waited. The tide began to go out, but would the gate hold? Well, now sure enough it did. Oh, there were some

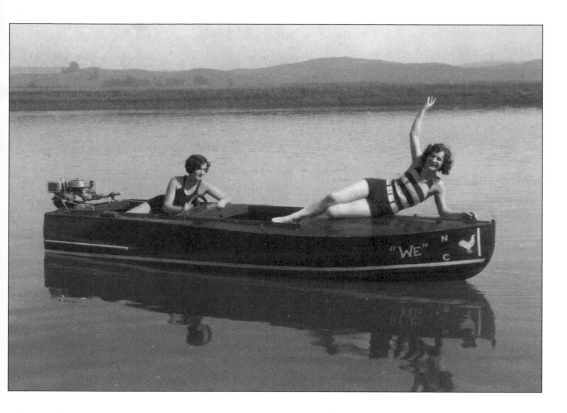

The Petaluma River was considered a placid, pleasant place where two young beauties could take out their boat, get some sun, and wave at friends. The "Melson, Ott, Camm Folly" briefly turned the river into a raging torrent. The young ladies enjoying the cruise are Elizabeth Frey at the helm and Topsy Hunt waving. (Petaluma Museum.)

leaks in it, but they were not too bad, and the main lot of water held.

"Finally the tide was at its lowest, and we decided to open the gate and let the water out. But there was one little thing we forgot, that is—how were we going to open the gate with 2-million gallons of water pressing against it? Of course we could not raise it, and so—*it was a flop.*

"But Bob Woods, an old friend who did hauling and trucking with a four-mule team, came by and spotted us so we had to tell him. 'Oh, he said, 'I can raise the gate, but it will be broken.' So he unhitched the mules, fastened a chain to the gate, gave the mules a 'go!' sign. Up came the gate, and, oh me, we were scared! A million gallons of water came down the creek bank going fast. It wrecked the watermelon boat just returned

from a trip up the Sacramento River to pick up a load of melons. The force of the water broke his tie ropes, spun his boat around and down the creek he went—he lost half his watermelons and he couldn't get the boat stopped until he got to Lakeville. But all the kids in town sure had a feast, picking up melons all along the creek.

"Did it clean the creek? I'll say it did, clear down to near Lakeville, and 14 rowboats up and down the creek went bye-bye too.

"Well, John and I were both very scared that someone in town would get wind of the crazy scheme so we did not tell anyone. I don't believe that until the day he died he ever told anyone, not even his family, and you can bet I didn't tell it.

"In our dilemma, a mutual farmer friend, Dave Risk, from out Corona way, drove up

31

and wanted to know what was going on. We told him, and he promised not to tell, but I said, 'Dave, wasn't there a cloudburst out on your ranch this a.m.?' 'Oh, yes,' he said, and we spread that story around. The papers got it, and the San Francisco papers did too: 'Cloudburst Hits Petaluma,' and so our lives were saved.

"John and I pledged each other that we would never reveal the real story of the 'Melson, Ott, Camm Folly.'"

LUKE TEDESCHI

Shortly after 1900, Louis Tedeschi became a familiar face in Santa Rosa, Occidental, and Healdsburg. Son Luke remembered those days:

"There was no money in those days. If you had a $20 bill you were rich! He [Louis] put in vineyard and made wood—he sold firewood. At that time everybody cooked with wood, and these hills [near Geyserville] were full of trees. He worked at the [Italian Swiss] Colony, and worked where he could find it, in his spare time. And little by little he put in more and more vineyard.

"[Wood choppers] would come over from Occidental. In the winter, they'd stay there at the hotel, they'd run up a nice big bill. Then in spring, they'd go out and work, and then they'd come back in and they'd pay their bill. You do that now, give a guy a whole winter for nothin', you never see him again.

"Anything that mother cooked was good . . . She didn't have recipes. She knew how to make meals with hardly nothin'. Go out in the garden, pick up a thing here, a thing there, make a big meal, and it was good. We didn't waste anything. If we killed a pig, we used everything but the squeal.

"Mostly we sold wine in bulk . . . You'd go down to Pedroncelli, he had it in gallon jugs. He'd just hand you a gallon jug. Now you have to have a paper around it and everything else. [Nervo] and Pedroncelli used to sell in gallon jugs . . . it was 75¢ a gallon."

RALPH GREEN

"Spring plowing is still a vivid image. My grandfather would plow in vetch; it was like a mulch used to help build up the soil. Seems like the plowing always took place during apple blossom time. I'd get to ride behind the plow horses with my grandfather. It was a beautiful sight. I can still see the strong sleek horses, the sweat glistening off their bodies, and on all sides were the delicate pink blossoms of the apple trees.

"My grandfather used to trade at Dennes and Haigh . . . [he] used to charge his purchases for the whole year . . . once a year he would go down and pay his bill. There were never any carrying charges. Everything was done with mutual trust. [If anyone] violated his trust . . . they were never trusted again."

LOUIS BOTTINI

The Bottini family moved to Healdsburg shortly after Louis was born in 1901.

"My father . . . used to play the accordion and one night he was asked to play for a wedding at Camp Rose. There was a short cut . . . by fording the river. When he crossed . . . there was no problem, but there had been a lot of rain and snow in the hills. While he was at the wedding the river really rose high and he didn't realize it. On his return trip the buggy was overturned. He was a good swimmer but he was with another man who wasn't . . . [and] both men drowned. My mother, Julia, was a pretty strong woman so she carried on. We had four hired men. They helped run the ranch."

CARROLL REINERS

John Reiners raised his family on Dry Creek Road near Healdsburg. He took direct action when animals invaded his yard.

"Skunks were always on the prowl 'round chicken houses, but so was Dad and his

shotgun. One night during setting season, he heard a commotion in the chicken house and he went into action. He not only atomized the skunk, but blew his little house to pieces along with the hens . . . my dad had a temper. The coop sat there for some time as 'a lesson for the skunks.'"

LINO BELDI

At least two John Pedroncellis, both from the village of Piantedo in Italy, came to Sonoma County. One owned a winery in Geyserville and the other worked at a mill in Duncan's Mills, later at the Pedroncelli ranch in Kenwood. The latter John Pedroncelli then moved to Willits in Mendocino County where he ran a dairy ranch for many years. Young Lino Beldi spent his summers on the ranch and remembered Uncle John as a no-nonsense type.

"On the ranch, John had 4 horses for plowing, he had a bunch of pigs, and about 60 dairy cows. When I would follow Uncle John around the barn he would warn me to stay away from the rear of the plow horses because they would kick. One time as I trailed along behind John I ventured too close to old Dolly . . . and she tried to kick me, thankfully missing. John turned around, went over to the horse, and punched her in the side with such force it knocked the horse completely down. I have never seen that happen in all my life.

"But that was nothing. Once I watched John kill a wild steer in his corral with a pitchfork. You didn't mess around with John Pedroncelli."

MARIE SNIDER GOSSAGE ON THE CAMPBELLS

"When we Snider youngsters were old enough to 'do,' we all had our chores and duties for every day. We picked prunes and grapes, sulphured vines as needed, and pruned. All the sulphuring was

John Pedroncelli (center) was an "amazing, charismatic man," according to Lino Beldi, who spent summers on the Pedroncelli ranch when he was a small boy. John poured at a family gathering that included his wife Mary (left) and daughter Lillie. (Pedroncelli Family Collection.)

done in the early hours of the day, beginning at 4 o'clock. When it rained in the middle of the night in prune season, we had to get up to help Papa stack the trays full of drying fruit . . . An unseasonal rain would cause the prunes to bloat and rot. Then we would have to 'pick-over' bloated and rotted prunes . . . to save the remaining good ones.

"Every fall Papa would butcher all our own meat, grown on the ranch. It would be after the frost so that the meat would cool out fast. Papa had some of the neighbors help, and Mama would trim the bacon, clean the casings, mix the ground meat with spices, and stuff the casings. Mama also would make liver sausage . . . cheese, and blood sausage. Papa would make us pointed sticks and give us a piece of lean meat trimmed from the sides of bacon that they were getting ready to render into lard. Papa had a smoke house where he cured all the hams and bacon and smoked the link sausage."

PETER TORLIATT JR.

"Us kids would go down to the river. They threw the watermelons off the boat to guys from the grocery store. When they tossed a melon we shouted, 'Drop It . . . drop it . . . drop it.' When somebody dropped one, we all dove in and ate all we could get our hands on. We ate the heart . . . that's all we ate; there were so many cracked ones we didn't have to fool around with the seeds.

"I dropped out of school in the fifth grade. [My brother] Charlie got me a job at the shoe factory. We started at 7 a.m. and worked until 5, and that was six days a week . . . we brought home all but $1 a week for my mother

Major Phillips of Healdsburg had a minor identity crisis as a child. He was called on to fill in as a substitute for a girl in his family until his mother finally had a daughter. Phillips' older brothers seemed more excited about the birth of a colt the same day the girl was added to the family.

[Adrienne] who put the money in a leather pouch. When she baked strawberry pie we each got one piece, and had to bid for the rest of the pie. Whoever made the highest bid, maybe a nickel or dime, got the pie; she put the money in her leather pouch."

MAJOR PHILLIPS

[After the family moved to Healdsburg in 1906]: "Ranchers from Skaggs Springs and the coast would herd their sheep down Dry Creek Road, and they would always stop at our barnyard and camp overnight.

"One day I was in the barnyard and being thirsty I leaned over the old wooden watering trough to drink some from the pipe. The troughs sometimes accumulated green moss on the inside wood . . . I slipped into the full trough. One of the hired help, a Mr. Yoakim, heard me splashing and yelling and pulled me out."

[Ten days after his parents had a 15th anniversary party] "the 'stork' delivered a baby girl to my mother . . . Mrs. Rose from Geyserville . . . was the midwife. That same day one of our mares gave birth to a slick little baby colt, 'Alberta.' My brothers, when they came home from school, were more excited about the colt than their little sister.

"Up to the time my mother became pregnant, I had filled in as a substitute for a girl. Pictures show I wore dresses [which was not uncommonly done in those days] with white lace collars, curls, and buttoned shoes.

"The average farmer was pretty much self sufficient, raising his own garden, family orchard, cattle for milk, butter, and beef, and pigs for lard. Lard was used to make soap in large iron cauldrons . . . They salt-cured the pork and dried it in well insulated . . . smoke houses . . . there was always a flock of chickens and turkeys. When unexpected company dropped in, either the wife or kids would run out, grab a couple of cockerels, ring their necks, dip them in hot water to loosen the feathers, and pluck them clean using a piece of burning paper to singe the

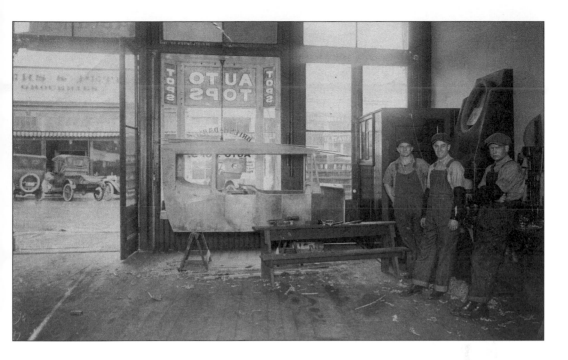

If there were cars, there had to be auto repair shops. Peter Torliatt Jr. (left) learned his trade as a body and fender man working for the partnership of Adolph Briesh and Jesse Dabner (center) in their 1920s "state of the art" auto repair shop at Main and Mary Sts. in Petaluma. (Torliatt Family Collection.)

feathers. Then we had a quick entree for dinner, with potatoes and gravy . . . [on Saturdays]; there was bartering of produce for groceries with the stores in town."

LEE TORLIATT ON SMALL TOWN LIFE 1920s–1940s

"My father, Peter Torliatt Jr., told me that he picked up the skills he needed to become an auto repairman because, when he was a young man around 1920, 'it was learn or starve.' He worked a few years at Jesse Dabner's shop where he learned how to pound fenders, spray paint a car, replace celluloid side curtains, and upholster seats and convertible tops. When he used sanitized tacks to nail the seat-cover material to the frames, he put the box to his lips and poured a batch of black tacks into his mouth. When I asked how many he had, with a glint in his eye

he would reply, 'Fifty,' and pop more uncounted tacks into his mouth. He opened his own shop on East Washington St. next to the Fior d'Italia Restaurant; the facade hardly matched the restaurant's romantic name. Later he moved his shop across the street to a combination restaurant-bar-hotel, which had been a very busy place during Prohibition. The building teetered on pilings out into the river, making it a convenient place to unload booze from boats.

"In those days, some of the grocery stores gave credit, but not the auto repair shops. My father had a sign on the wall that read, 'If You Believe In Credit, Loan Me $5.' At the end of each month, if customers had money on the books, my mother would drive around from house to house, knock on doors, and ask for payment. She usually got most of what was owed. When he closed his business in the 1950s, my father made the rounds and closed accounts with all but one

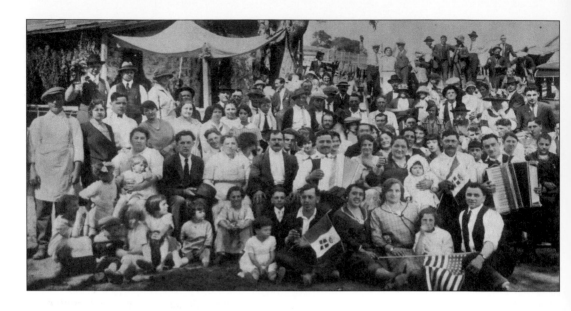

Before World War II, the "squeeze-box" was the king of instruments in Sonoma County. Accordion groups made money playing for local events and sometimes they played just for the fun of it. Italian Americans got together for flags, food, and music on a festive summer day in 1923. John Volpi, with accordion on right, was one of the noted accordion players of the day. (Volpi Family Collection.)

customer. 'I could have gotten that one if I wanted to,' he boasted.

"Our house at 115 Post Street, one of the finest on the block, was built in 1933 and cost $5,500. Other houses nearby were selling for $1,200 to $1,500. We had a large backyard, which included a chicken house and yard, usually a home for 15 or 20 hens. In between was a small kale patch for the chickens. Occasionally, my father would bring home a batch of fryers, fatten them up on wheat, mash, and kale, and then lop off their heads on a chopping block at the outdoor barbecue pit. He took the headless chickens into our basement, softened the feathers by soaking the birds in hot water, then picked, gutted and halved them. The wheat and mash for the chickens were kept in large galvanized cans in the pumphouse, which also housed the well my father had dug. It was my task to feed the chickens morning and night and collect the eggs. In winter, I went out early in the morning, grabbed the hoe, and cracked the ice in the watering trough.

"There was a good deal of live music in the old days. My father bought my brother Ken three different accordions, including a special one with reeds imported from Italy that cost $550, a princely sum in the 1930s. Ken started taking lessons from Guido Baccaleoni at age nine, and was tutored later by Dario Calegari and Sylvio Volpi. Lessons were $1 [a loaf of bread cost a dime]. Dario Calegari transported the group in a 1930 Chrysler, stuffing instruments and equipment into the trunk. Sometimes the group got paid, sometimes they didn't. 'It was hard to turn down a friend who asked you to play for nothing,' my brother said.

"A homing pigeon craze in Petaluma dated back at least to 1905 when poultry pioneer Lyman Byce and his two sons built pigeon lofts and imported a number of long-distance birds from other parts of the U.S. and Belgium. We had a pigeon nest in our backyard next to the chicken house.

"On race days, competitors put their birds on the Northwestern Pacific train that carried

them away 200 miles or more. At race time, the birds were released back to their home stations.

"Given the proximity of the river, it is not surprising that Petaluma had an active group of Sea Scouts during the 1930s. My brother Don was a member and performed in the Drum and Bugle Corps.

"The young seamen, operating from their ship *Chanticleer*, got a taste of real-life tragedy in March 1934, while cruising on the Petaluma River. Scout Art Bowdon spotted two males struggling in the water after their boat capsized near Gilardi's dock south of town. It was a father and son and both of them drowned. Sheriff Mike Flohr joined in the rescue try, got sick, and died shortly thereafter.

"The Scouts got a taste of show-biz when they arranged a behind-the-scenes look at the filming of the epic movie *Mutiny on the Bounty*, starring Charles Laughton and Clark Gable. Replicas of the *Bounty* and *Pandora* were brought to Drake's Bay in Marin County in April 1935, to shoot storm scenes.

"Many young people were active in scouting in those days, working on their merit badges and attending summer camp. Sonoma County youngsters went to Camp Noyo between Willits and Fort Bragg. In those days, the so-called Skunk Trains were cramped and used mainly for dropping off local passengers. With temperatures in the 90s, scouts deposited themselves and their luggage in the baggage car for the long trip to camp. Typically, when someone asked when they would arrive at Noyo, the answer was, 'It's right around the next turn.' It never was.

"The dehydrated food at camp was almost inedible, causing many Scouts to amuse themselves at mealtime by sabotaging the collapsible metal cups that came with mess kits. The sight of Kool-Aid spilling on wooden camp tables triggered shrieks of laughter.

"At night, as youngsters lay in their sleeping bags, huge lumber trains, with their big white eyes shining through the trees, labored along across the river.

"The Noyo River was our swimming pool. The daily campfires featured antiquated songs, gags, and skits. In one routine, two guys tossed water from buckets and then one guy grabbed a second bucket, aimed it and let fly at

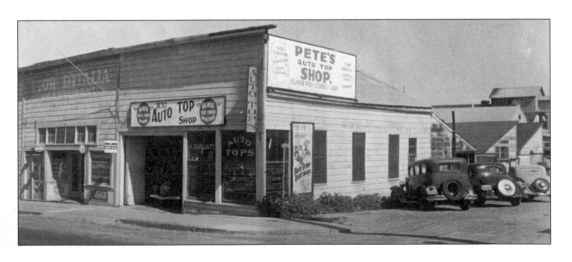

By the 1930s and into the 1940s, Torliatt had his own shop looking out over the Washington St. Bridge. The Fior d'Italia, in a building less fancy than the name, served food next door and the movie of the week was Buck Benny Rides Again, *starring popular comedian Jack Benny. (Torliatt Family Collection.)*

his opponent. Out came shredded paper.

Adult leaders kept the lads informed on world events, such as atomic testing at Bikini Atoll. One adult leader mounted the tree stump that served as a podium to report that 'Bikini Atoll is now Nothing Atoll.' All this for $11 a week and $4.50 for transportation, including the Skunk Train ride.

"For short vacations, many local folks went to western Sonoma County to enjoy the Russian River or the Pacific Ocean. For the big summer vacation, people sought out favorite fishing spots. That often meant salmon fishing trips to the mouth of the Klamath River near the Oregon border. There was heavy competition to bring home the best catch, but one night at our campground, everybody pitched in for a moonlight salmon barbecue. Fishermen donated their catch for the day and carved long wooden skewers to run through filleted salmon. The giant skewers were stuck into the ground around a great bonfire. The skewers were turned until the fish was done, at which point the salmon was quickly consumed."

Young sea scouts learned the ways of the water in the 1930s. They kept their vessels ship-shape, learned a bit about movie making, and were even pressed into rescue operations when boats capsized. During a relaxing moment Don Torliatt takes a picture of someone taking a picture of him. (Torliatt Family Collection.)

CHAPTER 3

Crime

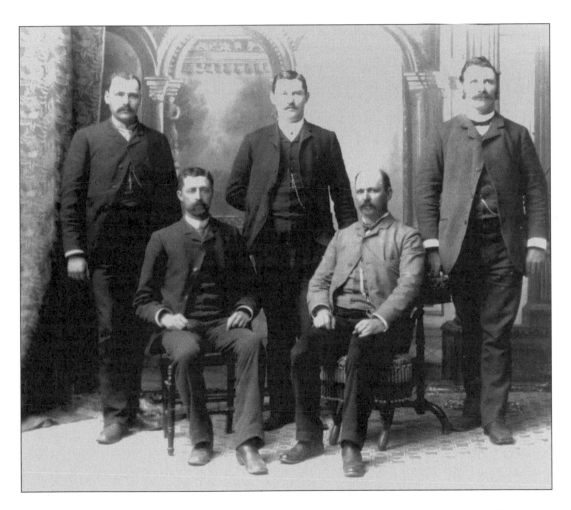

In the early days in Sonoma County, law enforcement was in the hands of Sheriff Edward Power Colgan and his posse. Colgan was in office from 1886 to 1890. From left: Deputy Hy Groshong, Deputy M.M. Vanderhood, Undersheriff J.F. Naughton, Sheriff F.P. Colgan, and unidentified deputy. (Sonoma County Museum.)

Communities took pride in keeping their hometowns safe and secure. A review from the Healdsburg area, with a population of 5,000, noted the city's success in controlling crime in 1896.

"The year of '96 with all its faults was propitious at least in one way . . . and that was the degree of sobriety that was maintained. With the revelry of the Floral Festival, the Democratic convention and the several campaign demonstrations there were only 48 offenders who were guilty of the charge of drunkenness. The other criminal cases are summarized as follows: disturbing the peace, 14; jumping off moving trains, 1; discharging firearms within corporate limits of Healdsburg, 1; violating hog ordinance, 1; petty larceny, 12; vagrancy, 11; robbery, 4; burglary, 3; threats against person, 1; battery, 13; assault, in the several degrees, 12; malicious mischief, 6; practicing medicine without certificate, 1; killing male deer, 1; obtaining goods under false pretenses, 2; indecent exposure, 3; trespass, 1; grand larceny, 1; defrauding hotel-keeper, 1; and obtaining money under false pretenses, 1. While crimes, however small in number, are not a credit to any community, compared with other localities Healdsburg [people] . . . have respected the laws during the past year admirably and if as good a record can be shown in the future people here may justly feel proud of their town from a moral standpoint, considering that the majority of the culprits were hoboes or non-residents."

In spite of Healdsburg's impressive numbers, there was a continuing need for law enforcement as Sonoma County entered the 20th century. In the early days, policemen often operated on foot. They walked their beats, outran the bad guys, or hitched a ride with a civic-minded motorist when they chased a culprit.

Their work was dirty, dangerous, and sometimes heroic. There weren't many of them around in the small towns of Sonoma County. The chief and a corps of maybe three or four men were responsible for protecting these communities.

One officer of note was Gus Jewett, who was born in Guerneville around 1887. He spent most of his life in law enforcement, mostly in Santa Rosa and Petaluma.

CHARLES TORLIATT JR. ON OFFICER JEWETT

"As a kid, when I lived in East Petaluma, my buddies and I walked to the old Cal Theater. When we came out at night, I usually saw Gus Jewett walking the beat downtown. He was a big moose, a good-looking guy. For us little kids, he looked like a king. He carried a club and had a big hat. He had an exciting life."

Two nights after he joined the Petaluma police force in 1915, Officer Jewett found himself in a shootout that left a fellow officer badly wounded.

"At 11:30 on Friday night, special officer Gus Jewett . . . met Officer Fred Rudolph and reported that two men had been acting suspiciously for several hours in the Hill park and vicinity . . . the two officers decided to investigate [and followed the suspects downtown] . . . [the two men] bumped into Officer Ed Husler in the middle of the street . . . the thugs quickly fired at close range and Husler, taken by surprise, grabbed for his gun and fell . . . Husler . . . fired three shots at the men as they ran. Officer Jewett was in the park when he heard the shots and ran quickly to aid Husler. As he fell Husler cried, 'I'm shot.' He was taken to the hospital and recovered.

In 1917, Jewett chased a knife-wielding San Quentin Prison escapee into a creek bed with near-fatal results.

"Officer Gus Jewett . . . is lying seriously wounded at the Petaluma general hospital as the result of a desperate encounter with Carl Otto, the most clever porch climber in the country who . . . escaped from San Quentin Prison.

"[During a search for Otto] Officer Jewett and Guard Gulde [from San Quentin] were on the road near the Dr. Beckwith place [in

Petaluma] . . . It was known that the man was small in stature, [and] was wearing a suit of clothing large enough for a 6-foot man.

"While the officers were at their post, they saw a man coming along smoking a cigarette and as Otto never smoked they let him pass and after he had gotten about 30-feet away they saw that he wore a suit much too large for his size and Gulde called, 'Halt or I'll fire.'

"The fellow . . . went into the bed of Thompson Creek . . . 'Don't go into the creek,' shouted Gulde but Jewett either did not hear or failed to heed the warning, for down into the dark bed he jumped. Otto . . . lunged at the officer and stabbed him between the ribs . . . and he also badly cut the officer's hand. He then dashed away and the officer, pulling his gun, emptied the weapon.

"[As Otto fled] Jewett and Gulde entered the auto of the latter . . . when Gulde saw that Jewett was bleeding badly. His uniform was soaked and his revolver covered with blood. The officer wanted to keep on but Gulde insisted on rushing him to the General hospital. The plucky officer was literally bleeding to death but he walked into the hospital and to the operating table . . . he asked the physicians not to inform his wife until after his wounds were dressed . . . "

Jewett recovered and Otto was later captured in San Francisco.

In 1918, popular sheriff-elect Jim Petray of Healdsburg picked Jewett as a deputy at the county jail in Santa Rosa. In December 1920, Petray and two San Francisco detectives were shot to death by San Francisco toughs hiding out in Santa Rosa. Petray's death engendered great anger and threats of revenge against the three men, Terrence Fitts, George Boyd, and Charles Valento. Talk of lynching was in the air.

Sheriff J.M. Boyes

A couple of days after the killing, in spite of pleas by Mrs. Petray and acting sheriff J.M. Boyes, a lynch mob formed. Boyes said

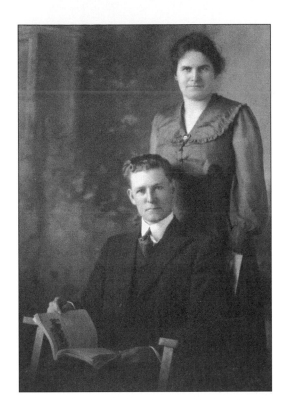

Gus Jewett and his wife Theresa were almost automatic winners of local dance contests but Jewett had more hazardous adventures as a policeman and sheriff's deputy. He almost lost his life when a desperate prison escapee known as "the most clever porch climber in the country" knifed him. (Torliatt Family Collection.)

he and the lynch party confronted each other at the county jail:

"At the time deputies Robinson, Lindley, and Jewett [who was a pallbearer at Petray's funeral] and three Healdsburg men . . . were with me on the main floor of the jail building . . . My revolver was taken from me and also the master key to the cell doors. This is what they had been after from the moment of entering the jail. I had taken the precaution every night since the triple murder to take up all the cell keys from my deputies, and secreting them where no one but myself knew where to find them. My deputies who were in the building when the lynchers

arrived, tell me that when the men first entered the jail they demanded the keys to the cells. None of the deputies had a key, though, and the masked men [who] did not know that others of their party were taking a key from me, declared that they were prepared for just such an eventuality and that they would burn the locks off with acetylene torches.

"As soon as the three prisoners had been taken from the jail and the crowd of some 400 men, including the 100 who had stormed the jail, had piled into their waiting automobiles and sped [away], I rounded up my men, but it was then too late to thwart the lynchers' plans."

Marcus (Mike) Flohr left his mark as a humane and fearless lawman in Sonoma County. After dodging death in a 1921 shootout, he went on to become Sonoma County sheriff. He died after a rescue operation in which a father and son drowned. (Sonoma County Library.)

OFFICER GUS JEWETT

Another account reported that it was jailer Jewett who had handed over the keys. Without mentioning the keys, Jewett said:

"About midnight, while myself and 10 others were on guard, the mob broke through the doors of the jail. The leaders of the mob said they meant business. I saw there was no use to offer resistance, so I fired no shots. It was but a few moments before the prisoners were in the hands of the mob. The prisoners . . . cried out for help but it was too late . . . " The three men were hanged in a Santa Rosa cemetery.

S.H. WILSON

Lynchings in Sonoma County were recorded well back into the 19th century. In June 1876, a "body of armed men" entered the Sonoma County Jail in Santa Rosa and hanged accused murderer Charley W. Henley.

Jailer S.H. Wilson told how it happened:

"At about a quarter to 1 o'clock [the night of the lynching] . . . some one knocked at my door and waked me up. I asked what was wanted and was told that they had a prisoner, and wished him to be put in jail. I went to the door, and as I opened it a crowd of men, all fully armed and masked, rushed upon and took hold of me. They told me they did not mean any harm to me, but that they had come to get Henley, and were determined to have him at all hazards, and ordered me to go with them and unlock the jail. They then guarded me to my room, four or five men going with me, and all having pistols in their hands. They stood by me until I had dressed. When I first opened the door, my wife I suppose hearing the men rush in, ran in where I was and screamed. The men ordered her to be quiet, and told her they did not intend any harm to any one at my house, but they had come for Henley, and the keys to the jail they would have. After I had dressed they marched me over to the

sheriff's office, having left eight or ten men to guard my wife and daughter. When we got to the sheriff's office, I opened it, and lit the gas. Then they ordered me to go and unlock the jail. I unlocked the first two doors, them following. They asked me where the cell was that Henley was in. I pointed it out to them. Two men then pointed their pistols at my head, and ordered me to unlock it. I did so. They looked into the cell by the light of a candle which they had. Henley was quiet. I suppose he was sleeping. Four men entered the cell, and took hold of him. When he awoke he said, 'Oh, Lord, boys, spare my life.' These were the only words uttered. He was then gagged, and bound hand and foot. Guards were standing all the way through the jail and sheriff's office, all armed with guns and pistols. Four men carried Henley out feet foremost. After they passed out, I was permitted to lock the jail doors, and was then marched into the sheriff's office, and saw Henley no more. Policeman Dyer, who was also under guard, and myself, were ordered to take seats in the sheriff's office, eight or ten men standing guard over us. We were kept there about half an hour. The men talked the matter over as to what to do with us—whether to lock us up in jail, or take us off. They finally concluded to take us into the country. A wagon was then driven up to the Court House door, and we were ordered to get in, and were driven to my house on Fifth Street where the guard which was left there to guard my wife and daughter, were taken in. They then drove down Fifth Street, turned south, and crossed the railroad near the depot and the wagon bridge over Santa Rosa Creek, and when near the timber on the flat they put us out in the road. About this time several wagons and horsemen came up. The men bid us good night and left, having ordered us not to make any disturbance or say anything about it in one hour, with severe threats if we did. They said there were one hundred and fifty of them. I don't know how many there were, but there were a great many. A few of the men done nearly all the talking. They called each other by numbers, as one, two, three, etc., and each seemed to understand what he had to do. They all wore black masks. They took a drink when they left. I recognized no one. They went towards [to the west] Sebastopol, and Dyer and myself came back to town and herded up Marshal White and Major Brown and told them what had occurred. I then went home until day this morning. I then sought Deputy Sheriff Lewis and told him to go hunt for the man Henley. The men said they came prepared to break into the jail if they failed to get me and the keys."

Henley's body, hanging from a limb on the bank of Gravel Slough in the west part of Santa Rosa, was found on the morning of June 10, 1876.

CHIEF MIKE FLOHR

The name Flohr has become synonymous with law enforcement in the Redwood Empire. Marcus (Mike) Flohr, a tall, angular lawman, distinguished himself as Petaluma's police chief from 1913 until he won the race for sheriff in 1930. His nephew, Melvin (Dutch) Flohr, was the longtime police chief in Santa Rosa. Mike Flohr was the man who first hired Gus Jewett. Like Jewett, Flohr risked death while serving his community. He almost lost his life on a summer Sunday in 1921 when a short, stocky man pedaled into town on a bicycle. The evening ended in a bloody shootout between the chief and a 28-year-old ex-convict named Roscoe Johnson.

A week earlier, while town folk were distracted by a local celebration downtown, Johnson committed a number of burglaries. He came back a week later with deadlier results. After a break-in, police began searching for the bicycling burglar. The trail led to an abandoned quarry south of town, "up a steep climb to the very top of the hill nearly a mile from the road." Below was the home of a man named Charles Walls.

Mike Flohr's nephew, Melvin "Dutch" Flohr, was a star football player at Petaluma High School and Santa Clara University in the 1920s. He came back to Santa Rosa to take the job as police chief and became a local legend during his 34 years in office. At 6 feet, 4 inches, and 250 pounds, Flohr easily intimidated football opponents and lawbreakers. In high school (left photo) Flohr was part of the David and Goliath team that included pint-sized scatback Rollie Webb. Webb, who later became a judge, didn't complain about the elbow on his head because Flohr was skilled in knocking tacklers out of the way. Later, the chief made extra money directing traffic for special events, such as the making of the Alfred Hitchcock movie, Shadow of a Doubt, *with Joseph Cotton (right photo). (Wilma Flohr Collection.)*

OFFICER ROBERTS ON THE GUNFIGHT

Officer Ernest Roberts, who was to become one of the heroes of the fray, told what happened when it was learned that the suspected bandit had been seen heading toward the quarry.

"When Chief Flohr came back for reinforcements, I went with him, as I am a sworn deputy, and we were accompanied by Deputy Sheriff Rasmussen and Traffic Officer Floyd Drake—Rasmussen and Flohr having rifles and Drake and myself revolvers.

"Chief Flohr sent Rasmussen to guard the hills to the south and Drake to the west and they left for these posts while Flohr and myself went up the hill, separating as we reached the first big ridge. Flohr was to the east and I was to the north and we were combing the hills and rock piles and clumps of trees as well as the old quarries.

"I saw the man I think before Flohr and started for him and a little later Flohr, who was closer to the man, saw him and got there first while I hurried up, after stopping at a trough to take a drink, as it was up-hill work and red hot.

"The man was feigning sleep as Flohr

reached him and called to him for he came up suddenly with his gun and let fly twice before the chief closed in on him and the man seized the chief's rifle. It was a short but desperate struggle and seeing the man trying to get his gun against the chief's body and realizing that he was desperate . . . I saw that I must act quick, but it was hard to get in a shot without hitting the chief. It was but a short distance away but every second had to tell . . . "

Roberts "let fly" with his revolver. He was "horrified to see that I must have hit the chief but was gratified to see a moment later that I had stopped the other fellow from shooting. We had to take his gun out of his hand and it still had three loaded shells in it and it was pointed right at the chief . . . it was either the thug or the chief and I had no choice. Better the criminal than Chief Flohr."

Later, it was determined that the ex-con's first shot had hit Flohr in the thigh. The bandit's next shot again struck the chief's leg. By this time, the thug had grabbed Flohr's rifle and held it away from his own body while trying to get in another shot. Roberts' shot winged Flohr, but hit the bandit in the throat. The policeman's second bullet struck Johnson in the head.

Roberts got Flohr to the hospital, where the chief confidently stated, "I am all shot up but am going to get well." The burglar died on the way to the hospital.

EDNA FLOHR

Edna Flohr remembered her father Mike mainly as a humanitarian.

"Sometimes he got involved in chasing down criminals, but mainly he supervised beat cops and did administrative work . . . My father reached out to runaway kids, especially those who left the facility at St. Vincent's [near San Rafael in Marin County.] He would never allow those kids to stay in the Petaluma jail, which wasn't really a jail . . . it was just three tanks . . . built in the middle of a room, bunks, I guess . . . He brought them home for lunch and they stayed until school people could pick them up."

MELVIN (DUTCH) FLOHR

He was called the Marshal Dillon of Sonoma County and he came by his law enforcement skills naturally. His uncle Marcus (Mike) Flohr served as both a police chief and sheriff in Sonoma County. He was a robust man, with a big smile, a sometimes quick temper, and a take-charge attitude. He was a football star in high school and at Santa Clara University, blocking and tackling viciously and sweeping opposing players aside. His name was Melvin (Dutch) Flohr and as far as law enforcement was concerned, he "ran" Santa Rosa for 34 years as its police chief.

Flohr first gained fame in high school running interference for a little scatback named Rollie Webb, who bore a resemblance to pint-sized movie star Mickey Rooney. After college, he brought his imposing presence to the Sonoma County Sheriff's Office and proved that when it came time to act, he was not afraid to assert himself.

FLOHR MEETS THE BATTLING BENNETTS

"The Battling Bennetts are back in the bastille. The pugnacious brothers, Floyd, 30, and Dan, 36, literally fought their way into the county jail cell . . . when one of the pair decided he didn't like Chief Deputy Melvin Flohr.

"[When the brothers made threats] a battle royal followed, ending only after the officer had pulled both his assailants over a wire fence and piled them in a heap."

Flohr, 6 feet, 4 inches, and 250 pounds, was named Santa Rosa police chief in 1940 and the job became his until 1974, when he retired. There were only 12,000 people in town when he was named to the post, very few murders, and little obvious drug use. Like many policemen of his time, Flohr believed in the informal approach to law enforcement, when it could be applied. A drunk might get a ride home rather than a trip to jail; a teenager in a

fast car might get off with a stern lecture. He could defuse a tense situation by putting a giant hand on the shoulder of a defiant young man while leaning over to provide a little heart-to-heart advice.

WIFE WILMA FLOHR

"Being police chief didn't pay a whole lot in those days . . . people saw him directing traffic at all the football games and even when they made that movie, *Shadow of A Doubt*, with Joseph Cotton. He did that to make a little extra money. I was in the hospital and I couldn't have gotten out if he wasn't out there directing traffic."

JUDGE JOE MURPHY

"Dutch was a very big man for his time, but he loved working with little kids, everything from teaching them how to box

to taking part in the Pet and Doll Parade. He was always the huge guy at the back of the parade. The kids were really awed when they looked over their shoulder and saw this giant looming over them."

OFFICER CARL MEISTER

Flohr's deputies, who rarely pulled a gun in the line of duty, remember that some of their calls were more bizarre than threatening. Bar owner Harry Quartaroli called at 2 a.m. one night for help in getting a patron to leave, complaining that he had been sitting there all night.

"The guy was cement. Solid as a rock. He'd been dead for hours, with his elbows on the bar. Rigor mortis had set in. We called Silvershield [the coroner] . . . We try to lay him on a stretcher and he's in the same shape as he was sitting there. We keep trying to flatten him out. And Quartaroli keeps talking about the customers who've been sitting on either side of him all that time."

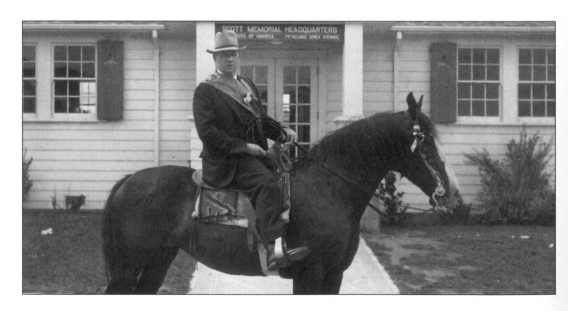

California Governor Frank Merriam showed up for the festivities when Sonoma County celebrated a convention of the Eagles fraternal organization and Flag Day in June 1936, but Police Chief Bob Peters was grand marshal of the parade. Peters was joined by Sheriff Harry Patteson and other dignitaries. (Petaluma Museum.)

CHAPTER 4

Fires and Quakes

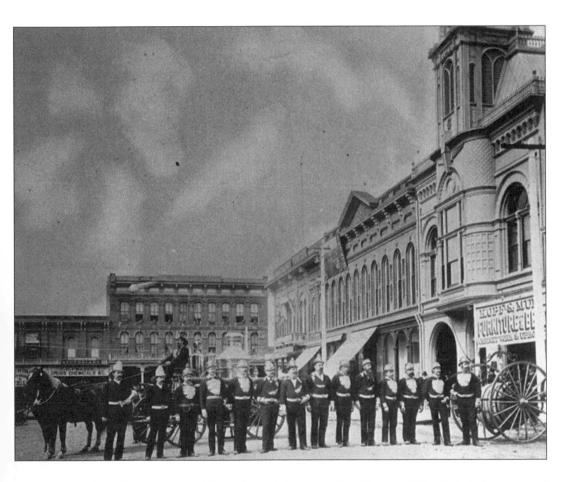

From the earliest days, since residents feared that a serious fire could level their homes and communities, volunteer fire departments formed in many towns. When they weren't fighting fires, the men ate, partied, and challenged rivals in nearby cities to friendly competitions. The Santa Rosa Fire Department gathered in the city center in 1884. (Sonoma County Library.)

Fire was an ever-present danger to early settlers. Fearing the spread of flames that might burn down an entire town, many communities formed volunteer fire departments as early as the 1850s. The units acted as social clubs and engaged in friendly but intense competition with each other. Time and again, the men also demonstrated their willingness to put their lives on the line when a fire threatened their community.

THE CAR FIRE OF 1912

A car fire in 1912 tested the mettle of Petaluma's volunteer units. By the time the episode was over, Petaluma's only paid

Morris Hickey Jr. almost lost his life fighting a car fire in 1912. In spite of his brush with death, he continued as a volunteer until the group broke up in the 1920s. (Torliatt Family Collection.)

fireman, James Mott, was dead and 30 others injured.

On Sunday morning, October 20, 1912, a nail in a workman's shoe had struck sparks as a Model-T Ford was being gassed up at Misner's Garage on Main St. When the sparks ignited spilled gasoline, mechanics pushed the flaming vehicle out into the street and rang in an alarm.

Mott hooked fire-horse Black Bart to his hose wagon and raced to the scene of the blaze, arriving ahead of hand-drawn equipment. The horse skidded twice on the pavement as he pulled the wagon to the fire. Four chemical extinguishers and a small hydrant stream were turned on the flames when a violent explosion ripped the car apart and a sheet of flaming gasoline shot from the rear of the gas tank. Fully exposed at close range, Mott, 57, took the full force of the blast. He died 48 hours later. Among the others seriously injured were Morris Hickey Jr. and Mayor William Zartman.

Eyewitnesses reported:

"The gasoline tank blew out with a roar that shook the city.

"The firemen turned into human torches . . . Morris Hickey started up the hill looking like a human torch. Somebody overtook him, knocked him down, and pulled his burning clothing off him.

"Mayor Zartman had his clothes pulled off . . . after they hurried him away, his shirt was still burning on the street.

"Poor James Mott . . . was placed face downward, the only position he could endure, and a two-horse express wagon raced him to the hospital.

"Cars seemed to come from everywhere to take victims to the hospital.

"Doctors got called out of church and from their breakfast tables."

"Will Brandon stripped to the waist was led to an auto and his face and body resembled that of a [black man]. He was not recognized by his friends."

As the lives of several volunteers hung in the balance, Mott's funeral was held Oct. 24. "Not a bell was tolled, not a dirge was heard"

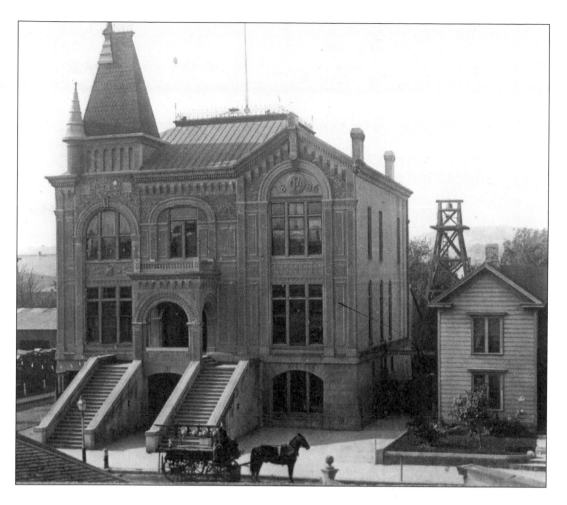

Black Bart and his driver pulled up in front of the old Petaluma City Hall-Fire Station. Bart lost his master James Mott in a car fire and explosion in 1912. (Petaluma Museum.)

for fear it would demoralize the men still in the hospital who had not been told that their firefighting friend had died. The funeral procession included men of the volunteer fire units. Black Bart pulled the hose wagon filled with floral offerings. Mott's cap and coat were placed on the driver's seat. Hickey, Zartman, and all the others involved in the fire eventually recovered. Hickey, a supervisor for Pacific Gas and Electric Co. and the city electrician, carried the glow of his burned skin the rest of his life.

Ironically, only a short time before the fire, the city had proudly acquired state-of-the-art equipment, but it was not ready for use. A Nott gasoline-powered fire engine was in the garage for repairs. According to Norman Caspadus, author of a history of the fire department, mechanics found a large wad of cotton in the oil feed line to one of the cylinders. The Argus newspaper suggested the offending piece of cotton "could not have gotten there by accident." If the machine had been in working order, tragedy might have been avoided.

To many Petalumans, the fire department in 1912 was a two-man team, Mott and his faithful steed, Bart. Readers were frequently amused by stories that extolled Bart's almost-human qualities.

" . . . The city of Petaluma purchased for the new hose wagon the finest draught horse seen here in many a day. The horse was bought from Robert Keyes of Bodega. 'Black Bart' is the name of the new fire horse and he will soon be the pet of the whole city. Although quite thin, 'Bart' weighs over 1,500 pounds. He stands 17-hands high, is big and rangy, and is coal black with white face and white feet. He is gentle as a kitten."

"Bart, a smart and persistent animal, quickly overcame his country habits and learned to respond to the fire bell, jump into place beneath the swinging harness and gallop into action . . . The firemen needed no alarm clock when Bart was around. Every morning at 6 o'clock he would walk to the bunk of his driver and awaken him, and if the driver feigned sleep, Bart would pull the bed clothes off the bed.

"[One New Years] . . . when somebody ran into the fire station and rang the gong on the wagon footboard at midnight, Bart dashed from his stall and went through the chains of the front door as if they were threads. He ran up the street and rolled and snorted and kicked up his heels in glee . . . driver Mott gave chase and in half an hour caught him near St. Vincent's Church. As Mr. Mott led the big black back to his stall, the animal winked at the crowd. So Jim [Mott] says."

In the fire that cost his master's life in 1912, it was noted that Bart had fallen twice and then galloped away from the fire just before the explosion.

THE SANTA ROSA HIGH SCHOOL
FIRE OF 1921

A late-night fire destroyed the stately Santa Rosa High School building on Humboldt Street November 15, 1921. No one was hurt, but the all-wood structure burned to the ground. Witnesses said they could see the fire 2 or 3-miles away and there were several loud explosions, probably coming from the chemistry lab. Fiery embers were seen floating 4 or 5-blocks away, but there were no other fires. Several students who were loitering nearby ran into the building to save trophies and football uniforms. There were numerous busts of famous historic characters that went up in flames. Bystanders cheered as each

After Santa Rosa High School burned down in 1921, student Raymond Clar, who commuted by train daily from Guerneville 25-miles west of Santa Rosa, did a sketch and poem that appeared in the 1922 Echo Yearbook. The poem reads:

OUR MEMORIES SHALL TURN THROUGH THE SWIFT

PASSING YEARS

AND PICTURE GLAD SCENES WE RECALL NOW WITH TEARS.

THE BUILDING, LONG HALLOWED BY FRIENDS THAT ARE TRUE,

NOW BLACKENED AND DESOLATE SADDENS THE VIEW,

AND YET THROUGH THE TANGLE OF RUINS WE SEE A

BEAUTIFUL VISION OF WHAT IS TO BE . . .

After the disastrous fire at Santa Rosa High School in 1921, a new school was built at a new location on Mendocino Avenue providing a major boost to faculty morale. Teachers often considered themselves role models and school was believed to be a place to learn proper manners and follow the sage advice of adults. The formality of dress was displayed by the Santa Rosa High School staff when it turned out for its 1927 yearbook picture; the men wore suits and ties and the women wore suits, dresses, and fur wraps. (Santa Rosa High School Foundation.)

heroic figure fell to the ground.

The most likely cause of the fire: faulty wiring.

HARVEY SULLIVAN, STUDENT

"We were having a fraternity meeting at my house when we heard the school was on fire . . . it was a sight to behold. There was a bust of Shakespeare and other famous men all around the building . . . three busts on each side. Down goes Abraham Lincoln. The cheerleader yells, 'Six for Abraham Lincoln.' And we'd cheer.

"It was difficult for teachers and students [after the fire]. There were classes in buildings all over town. We had a 20-minute break between classes. A lot of kids had trouble getting back and forth. For some kids, it was a picnic [because they didn't go to class]."

MARTHA ERWIN, STUDENT

"It was a dreadful fire. It burned all night long. We had classes at the Congregational Church, at the Masonic Temple, and at Mailer-Frey Hardware Store.

There were classes in one building next to the jail. Some people really had to run to get from one class in the school annex to another one downtown. We had to have much longer passing time [to get to the next class.] It was very fine socially getting from class to class."

RAYMOND CLAR, STUDENT

"News came by word of mouth to the river (at Guerneville). When we got on the train to go in the day after the fire, nobody knew about the fire. We got off the train, walked up 4th Street and saw smoldering ruins. There was a great mystery about how the fire started. A fellow from San Rafael Military Academy told me years later that there was a game that day and somebody may have turned on the heaters [for showers] and forgotten to turn them off.

"It was sad. I did a sketch of the school and a poem for the 1922 Echo [Yearbook]."

THE CONTINENTAL HOTEL

One of the Redwood Empire's most imposing landmarks from the 1870s and on was the Continental Hotel, which anchored the southwest corner of Kentucky Street and Western Avenue in Petaluma. The hotel originally had been located in Chile, but buildings were moved in those days, and it ended up reassembled in Petaluma in the 1870s. It lasted almost 100 years on the same site until, empty and condemned, it burned to the ground on a Sunday morning in 1968.

"The fire destroyed the ancient Continental Hotel and four businesses located on the ground floor of the building . . . the hotel was unoccupied but furnishings were still in the rooms . . . timbers crashed from floor to floor and into the street and several firemen escaped serious injury by running away from crashing walls. One fireman reported that he and two other men were handling a hose near the building when they heard a crackling

sound and looked up to see a wall beginning to shake. The firemen turned and fled, dropping their hose and the huge piece of second and third story wall came crashing down into the street . . . the rubble buried the hose and the place [where the firemen] had been standing."

The hotel had a handsome tower 16-feet high, erected atop the building in 1875. There were 50 to 60 rooms with nearly 100 windows looking out on downtown Petaluma. The owners boasted that "the sun will shine on each room during some part of the day."

KEN TORLIATT ON
FRANK AND SADE STEWART

Longtime residents Frank and Sade Stewart took over the then 64-room hotel in 1933.

"There were several big stuffed chairs in the lobby. The regulars looked out through large plate-glass windows and watched Petaluma passing by. The staircase to the second floor was very wide and had a thick wooden bannister. When we were teenagers, my brother and I worked for Frank and Sade, who were our uncle and aunt. When we got tired, we climbed up to the cupola on top of the building where we took a break without being disturbed . . . There was a real mix of characters, including a guy named Miller who worked at the overall factory, who was there for years and years . . . when the circus came to town, the performers stayed at the Continental. The midgets got a lot of attention from the local folks.

"When Frank and Sade had the hotel, Hans Andresen opened a bar next door. There was a door connecting the hotel and the bar. That made it easy for people to slip into the bar without being noticed. Frank didn't drink much . . . his wife watched him to make sure he didn't stray. One night, I was working there and Sade couldn't find Frank. She decided I should try to find him. I went from room to room and I couldn't find him anywhere. I had just about given up when I

Long abandoned, the Continental Hotel was totally destroyed when it caught fire on a Sunday morning in 1968. Photographer Chris Mannion caught the scene as the wall of the hotel buckled and sent firefighters fleeing from the debris. (Chris Mannion Photo.)

entered a corner room on the second floor of the hotel. There was a big lump under the carpet. It was Frank. He was out like a light. Andresen's was too much for him."

At times, the hotel featured some memorable food.

"In the Continental Hotel on the Western Avenue side was a Chinaman. He served both Chinese and American dishes, but I went there for chow mien. You know, the dish composed of all vegetables, shoe-string potatoes, bamboo sprouts, onions, and others that I don't know the name of. I've eaten this dish all over the country—Boston, New York, and San Francisco—but I think his was the best."

THE GREAT QUAKE OF 1906

The Great San Francisco Earthquake occurred shortly after 5 a.m. April 18, 1906. Hundreds of people were killed by the quake and fire that followed. In addition to San Francisco, the temblor caused major damage in a number of areas, including San Jose and Sonoma County, especially around Santa Rosa.

The 1906 earthquake did major damage to Santa Rosa, leveling most of the city and demolishing the Sonoma County Courthouse. The official death toll was 60, but other estimates indicated the number of fatalities may have been as high as 150. (Healdsburg Museum.)

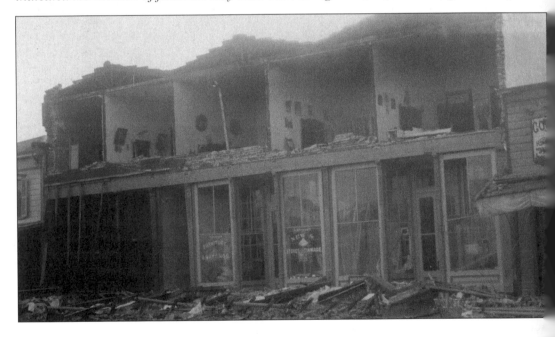

The Gobbi Building in Healdsburg got an open-air look during the great quake of 1906. Healdsburg—16-miles north of Santa Rosa—suffered few injuries but substantial property damage. (Healdsburg Museum.)

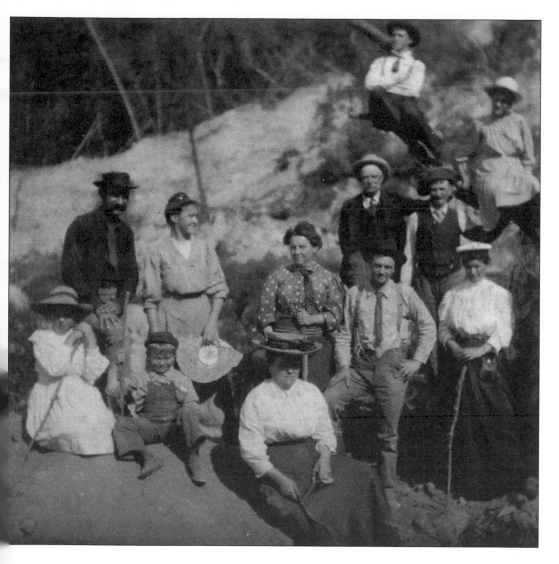

The quake caused a slide on a Healdsburg hillside, creating a perfect spot for a visit from local curiosity-seekers. (Healdsburg Museum.)

THE SANTA ROSA QUAKE

"A frightful disaster overtook Santa Rosa yesterday. Just as the dawn was breaking, a mighty earthquake struck the city. It came with awful force and suddenness, hurling many people from their beds. Before the terrified community could realize what had happened, the entire business section was a mass of ruins, every residence had been . . . damaged, some being completely wrecked, and approximately half a hundred or more people had been swept into eternity. Flames immediately broke out in all directions and lent additional horror to the scene."

NORTH OF SANTA ROSA

"Tuesday evening, April 17th, 1906, was as fair and pleasant as one could

desire, but later in the night the atmosphere grew warm and sultry . . .

"At 5:13 Wednesday morning the shock occurred. It started quite gently, but quickly increased, until it became absolutely terrific in its force. It was accompanied by a fearful noise . . . interspersed with the crash of falling buildings.

"Chimneys went down by the hundreds and weak structures collapsed. Along the Russian River and Dry Creek bottom lands the earth opened . . . near the Bidwell place . . . many trees were torn up. The long bridge crossing the river in Alexander Valley was thrown down . . . rocks were heaved from

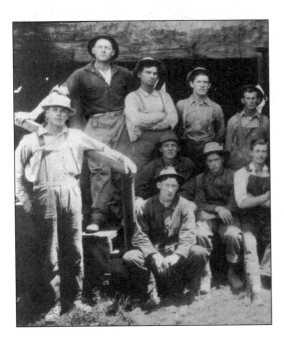

Wade Sturgeon was tossed out of bed by the 1906 temblor but went on to operate Sturgeon's Mill in Coleman Valley near Occidental in the early-20th century. The mill crew included, top row, from left: Wade Sturgeon, Frank Craig, Walter Withem, and Mr. Clark; (bottom row) John Heintz (standing), Frank Billett, Mike Horgan (below Billett), Charlie Anderson, and Cornelius Ihm. (Sonoma County Historical Society.)

their beds on Fitch Mountain and rolled down into the river.

"Shocks were felt at intervals for several days, but they were slight, and did no damage . . . In Healdsburg . . . every brick building in town was more or less damaged . . . fortunately, no lives were lost."

WADE STURGEON

Wade Sturgeon experienced the quake on his farm near Occidental.

"Esther had just cooked breakfast and was about to call me when the shock came. I was upstairs in bed and after the first shock was thrown out of bed and bumped around, but managed to fall down stairs some way. I grabbed Esther and got her outside and then rushed back in and grabbed a blazing lamp and carried it out and after the shocks I managed to beat out the flames. I . . . went to the Benninghovens [neighbors] and found them safe but the chimneys and everything shook down. Everything in our house is shook to pieces and the house is off its foundation . . . Esther and I sat out in the front yard. There were about fours shocks after the main one, which occurred by our clock at 5:13 a.m. I removed a piece of glass from my foot and think myself very fortunate that I came off so lucky as I walked all over the stuff in my bare feet. We could see a big fire in the direction of San Francisco and Santa Rosa. The one toward the city resembles a volcano it is so large . . . Just about dusk we had another shock and the folks decided to stay in the orchard tonight [Neighbor] Walt and I built a bonfire and we gathered around that . . . the hotel at Duncans Mills was wrecked and two persons lost their lives. The Duncans Mill, Willow Creek Mill, and other structures up that direction were ruined."

hree members of the Gonnella family of Occidental dressed up and went to San Francisco o check the damage shortly after the quake in 1906. From left, Oreste, Deonisio, and ?ompeio Gonnella stop at an arcade during their visit to the big city. (Sonoma County listorical Society.)

BARNEY BARNARD

"I was in that two story log house on the Flat Ridge and I was sleeping across the nain front room. Dad came across to see ow I was making it. The log house was put ogether with pins and it squeaked and roaned. I didn't know what an earthquake as—you know, mountain kid. He opened e door and the dresser rolled right in front * it. He rolled the dresser out of the way to ome over to see if I was all right, and boy, as I glad to see him."

LOUIS BOTTINI

"I was sleeping in bed and the bed started rocking. I was half asleep and thought I was riding a train. Then the bed began to move from one side of the room to the other. One of the hired men came and took me outside. Out there the animals were all going crazy."

HENRY SCHLUCKEBIER

Henry Schluckebier, on a post-quake trip to the coast near Olema, found the landscape distorted.

"A large tree that stood at one corner of the creamery building [at Skinner Creamery] now stands at another corner of the structure. It moved with the ground about 30 feet. It is still upright and growing . . .

"I heard that a cow got swallowed up at the Shafter ranch and it seems to be true. I was told the cow was in the corral when the earthquake hit and the earth apparently opened under her feet, pitching her head first into the crevice. The earth closed in on her after the shock, and only a small portion of the cow is sticking out of the ground . . . "

WHAT THE WOMEN DID

Correspondent Dorothy Ann told about the way the good women of Santa Rosa rallied together to help survivors.

" . . . I am not the only one who saw with surprise how our society women rose to the occasion—forgot themselves, their good clothes, and their beautiful homes when the necessity demanded it.

"One of the first people I met on that fateful Wednesday morning was Mrs. John Overton. She had reached her mother's home in less time than I can tell it to you . . . she was caring for the injured so busily she had no time to think of their own serious losses. Mrs. Edwards' house was turned into an impromptu hospital. Into this beautiful home and over the soft carpets were carried the maimed and injured, notwithstanding the fact that they were covered with blood, dirt, and plaster.

"Miss Edwards said the thing that worried her most that morning was a poor little Japanese, who lay out on the lawn badly injured, dying, as she thought. She felt someone ought to hear his last words. She asked a Japanese looking personage passing to come in and talk to his friend, but was promptly informed in excellent English that he was Chinese, not Japanese, but that he would do what he could.

"[When] Mrs. Edson Merritt . . . reached the 'brick piles' that had been our business section she had with her a grip filled with yards of bandages, which were quickly put to use by the doctors. Afterwards she was seen . . . serving coffee to those fighting fire and doing rescue work.

"Mrs. Dougherty's . . . small boy, Sam, is the only one I have heard of who enjoyed the shake . . . But when the little man went down town and saw his father's building in ruins he wept disconsolately, and wailed: 'we haven't got any office! We have not got anything more!'

"Mrs. S.S. Dunbar is one of the real heroines of the calamity. To her . . . little Reynolds Dunbar owes his life. The falling chimney which struck the bed on which she was sleeping with her grandson would have killed the little boy . . . had she not thrown herself over him . . . the wound she received is healing nicely.

" . . . Isn't it worth while, even if our business section does look like a cross between a mining camp and an Italian fishing village, with a churn house thrown in. Isn't it worth while to know that our society women, that dress well, dance well, skate well, play cards well, and entertain well, can work well—not only can work, but did work tirelessly, faithfully, and cheerfully."

CHAPTER 5
Education

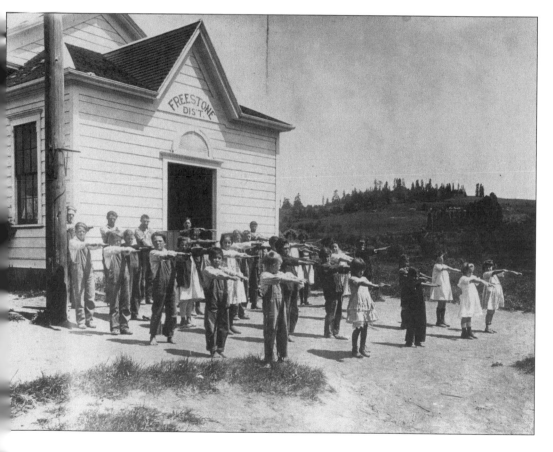

One-room schoolhouses served the needs of children of many ages, attempting to meet their mental, moral, and physical needs. Teacher Louis Witham's classes lined up for exercise at the Freestone District School in west Sonoma County. Some students—like Stewart Wade of Healdsburg—milked cows at home before starting the stove and doing cleanup work at school. After school, Wade rushed home to round up the cows and handle other chores. (Sonoma County Historical Society.)

School Memories

Stewart Wade

"We would be up and at 'em at 5 to 5:30. Went outside and then take milk buckets to barn. Feed the cows and milk them . . . We would then take the milk to our home where we had a hand-turned separator . . . we would thoroughly clean the separator parts. Bob [Stewart's brother] would take the skim milk and feed the pigs. I would put the cream in the 5-gallon can, then once every two weeks we took it to town and shipped it by train to the cheese factory in Petaluma. After wood was brought in for cook stove and fireplace, we would clean up and change into our school clothes.

"After running our trap line on the way to school, we would do the janitor work. This consisted of bringing one or two buckets full of water from a spring that was located down an abandoned road. Then we would sprinkle oiled sawdust on the school floor and sweep it up, clean the blackboard, dust the desks, and bring in wood and start the stove.

"After school we would scoot [sometimes] for home, where mother many times had fresh baked rolls or other good things to serve us as we had only had two sandwiches since breakfast. Then I would go after the cows . . . many times I didn't get back until after dark. On wet, dark, rainy nights I would hang onto a cow's tail and they would lead me home. After milking and separating the milk, we would wash up and all sit down together for dinner. After dinner Bob and I would do the dishes. Then the good part would come: we would read together or separately till 9:30 or 10. We were always ready for bed by this time."

"Driver Frank Lynch [who took the youngsters to school in a wagon] . . . was a slightly built man who [was] . . . always called on to shinny up our school flag pole when we were careless enough to pull the rope through the pulley."

Louis Bottini

"Things got a bit more difficult for me when I started school. In the first place, we only spoke Italian at home so I didn't speak any English. The kids made fun of me. They called me Zucchini Bottini . . . and would steal my lunch. I was bigger than most kids so I usually could hold my own. However, one day after getting beaten up and having my lunch stolen, the Chinese man who owned the Chinese restaurant saw me and asked what had happened. He took me into his restaurant and gave me a great meal. I guess he could identify with being different."

Major Phillips

"[At age 10] my lifestyle changed. I now wore a shirt and bib overalls, milked the cows, fed the chickens, and walked 1 1/2 miles to and from Dry Creek School. The same old one-room, one teacher, and eight grades. It hadn't changed since my folks attended there in the 1860s and 1870s. Same old wood stove and desks, same old salute to the flag, same old slate boards with chalk and erasers. Eight classes reciting the 3 R's with a little history and geography thrown in and a spelling bee every Friday afternoon.

"Each [school] had its own bell and belfry, a wood stove, and 'Chick Sales' outhouse one or two-holer type with a crescent shaped sawn hole on the side and the old Sears Roebuck catalogue hanging on the inside wall in lieu of toilet tissue."

On Eloise Batchellor Hoffman

"Eloise was another student who walked to Daniels School [outside Healdsburg]. She made the 5-mile trip each day until she was in sixth grade. That was when she started riding her pony to school. The pony spent the day waiting for Eloise

under a tree down toward the creek where he enjoyed oats for lunch. Another rider was Florence Nylander. She rode her small horse on the 12-mile round trip to school."

Ken Torliatt

"**I** expected special treatment when I got assigned to [Mrs. Stewart's class] at Lincoln Primary. After all, she was the principal and since she was my grandma, I thought I could do whatever I wanted to do. They had a very strict rule, no bikes on the schoolground . . . but I knew that didn't apply to me. I went riding all across the playground, went into class, and then came out to get my bike. It wasn't there. I thought it was stolen. When I told her, she said she had told [the custodian] to lock it in the storage room. I didn't have my bike for two weeks. I didn't talk to her for awhile but she didn't care. That was the last time I rode my bike out on the playground. She was strict but all teachers were in those days, and I think they taught the kids a whole lot more."

Robert Young

"(**A**t Halloween) we often would walk out around the Valley and by the school. We'd climb up in the bell tower and tie the bell so it couldn't be rung the next day to call us all into class.

"On the way home [from school] we often stopped and played in Gird Creek. It had a lot of beautiful trout, so we'd bring along a burlap bag or two, prop open the end with boughs, and then chase the fish into what looked like good hiding places, but which were really our bags. We caught quite a few that way."

Barney Barnard

"**I** wasn't in high school. I had to quit two months before I graduated from grammar school . . . So my education has been practical experience. I tell you, a lot of these guys has got all the common sense educated right out of them."

The Dropout Class of 1902

When it came time for graduation at Petaluma High School in 1902, it looked like the audience might end up looking at an empty stage. High school classes were small in the early days of the 20th century, but in 1902 there was one that almost disappeared by the time it reached the 12th grade. The word "dropout" may not have been used in those days, but it was certainly an appropriate word for the class of 1902.

Elizabeth Hickey Stewart worked for many years as first grade teacher and principal at Lincoln Elementary School in Petaluma. At first, she rode a horse from her father's ranch to get to her job. The pay was $70 a month.

Zada Smith and Sarah Boekenoogen became friends in their senior year at Petaluma High School in 1902. It was a good thing. They were the only two certain graduates from a class that went through a meltdown between the 9th and 12th grades.

The lack of seniors presented problems, not the least of which was production of the school yearbook, *The Enterprise*. Senior Zada F. Smith was the editor. Directly above her name, it was noted that *The Enterprise* was being "Published by Senior Class with aid of Juniors."

In the yearbook, it was explained how the "dropout class" had melted away.

"When we graduated from the Grammar School there were 35 of us . . . 26 entered the high school. Such a number of 'giddy freshmen' . . . was an encouraging sight.

"At the beginning of our sophomore year there were 10 of us. Some left school, but almost half of our classmates found [formed] the nucleus of the commercial class, which was then established. During the year two or three left us. We were first six, then five, then four, and then three juniors.

"We Seniors, two in number, were jubilant when Miss Cora Perkins, from the Salinas High School, came to swell our numbers. Our delight was short-lived, for she, too, deserted us. So now you see the class as it is; the remnant of 26 freshmen. That you may know who and where the others are, they have been searched out and their names here appear:

"Allie Anderson is at school and hopes to

By the mid-1920s, Elizabeth Hickey Stewart (top left) had traded her horse for an automobile to transport her to school. Unlike teachers in the one-room schoolhouses, she had the advantage of teaching at one grade level at Lincoln Elementary where she saw many children through the school system between 1905 and her retirement in 1937. (Torliatt Family Collection.)

For many youngsters in the early days of the 20th century, the eighth grade was the end of the educational process. Graduating from high school was just a distant dream. In the agrarian economy of the time, many youngsters went to work as early as the fourth or fifth grade. There were 40 graduates in the Washington Grammar School class of 1912. (Torliatt Family Collection.)

graduate in '03.

"Will Lewis was at school for three years, but then work in San Francisco became more attractive to him.

"Lottie Pressy lives with her parents on a farm near town.

"Pearl Winans left us at the close of her third year. She is now training for the stage and we hope to hear soon of a brilliant success.

"Ed Hussey is at work with the Electric Light company as lineman, in town.

"Ruby Fairbanks, who is living in Willitts, occasionally visits her old home.

"Lena Hanger, about a year ago, tired of her surname and changed it to Pomeroy. She now resides in Oakland.

"Emma Steffes graduated last year from the Commercial Class and is book-keeper at the Maze.

"Gertrude Coate graduates from the Los Angeles High School this year.

"Edna Peoples is at Dr. McNutt's hospital in San Francisco, training to become a nurse.

"Davitt Melehan is working on a sheep ranch in the mountains.

"Alberta Kopf for a time attended the Santa Rosa Business College. She is now keeping books at Horn's Real Estate agency.

"Elsie Kuffel has learned the millinery trade and is filling a position in San Jose.

"Walter White is in the southern part of the state in the employ of the railroad.

"Etta Friggens is in Woodland with her parents.

"Lottie Anderson has been in the San Jose

Outside of the classroom, it was "cool" to have a car available to drive to school and take friends for a spin. Teresa Sullivan impressed her classmates as she drove a custom Speedster, probably a 1920s Ford. She and a friend relaxed c. 1926 in front of the Santa Rosa High School annex, currently the location of Fremont Elementary School. (Santa Rosa High School Foundation.)

Normal for three years and expects to finish next summer.

"Rudolph Meyling is transacting commission business on Washington Street.

"Because part of the year was spent in Europe, Tessie Sweed was unable to graduate with us . . .

"Clara Johnson was married three years ago and went to Honolulu to reside. She is still there with her husband and little boy.

"Nellie Hall is in San Francisco working at her chosen trade, that of a milliner.

"Arthur Connolly is also in San Francisco at work.

"Nellie Knowles is living at home in Blucher valley.

"Lulu Parker is in the northern part of the county.

"Ed Kelsey left school at the end of the freshman year and is now in the city."

When graduation night came, there were six students on stage, Zada and Sarah, three seniors from the Commercial Class, which had also had a large dropout rate, and Tessie Sweed, who made it back from Europe just in time for the ceremony. It probably didn't hurt that her father was president of the school board.

CHAPTER 6

Seeing the World

*s automobiles and trucks replaced the horse and buggy, the Russian River near Guerneville
ecame an easily accessible recreation site in Sonoma County. Peter Torliatt, Ethyl Stewart,
nd Cletus Ward enjoy a float on their inner tubes in the 1920s. (Torliatt Family Collection.)*

Americans have always been travelers. Many came by ship to settle the country and then utilized horses and wagons and trains to cross the continent. Later, the settlers of the Redwood Empire found ways to make connections between communities and finally moved out across the seas again.

There were always perils on the trail:

"John Walker of Analy Township [Sebastopol] was returning home from Santa Rosa. His horses ran away and seeing his horse and buggy were about to come in contact with a stump, he jumped out. He slowly recovered from a severe gash on the leg.

"A horse attached to a wagon belonging to B.F. Clement, a sewing machine agent, became frightened at the [presence of a] street car and ran upon the sidewalk . . . and fell, turning the wagon completely over, and spilling Mr. Clement and a sewing machine, demolishing the latter, breaking a shaft and the dash-board of the wagon . . . Mr. Clement . . . was dragged under the heels of the horse nearly 20 yards."

Sometimes, the consequences were more serious.

"Prominent rancher Peter Mathison . . . was driving home in a buck board loaded with several sacks of feed and at the Corliss Bridge [west of Petaluma] . . . hit a chuck hole or the side of the bridge and was catapulted . . . into the water, striking on his head . . . he was discovered two hours later by neighbors . . . it was necessary for the Coroner to raise the body with ropes."

PAT SCHMIDT ON FRED PHILLIPS

"The biggest event in Grandpa's [Fred Phillips] young life was the year the railroad came to Healdsburg and Geyserville in 1871. Mr. Peter Donohue, owner of the line, invited everyone to be his guest on the line. Everyone able accepted. Flat cars were fitted with benches and everyone climbed aboard, many of whom had heard of, but had never ridden on, a train . . . at Donohue's Landing [south of Petaluma], men, women, and children scattered to see the sights.

RUNNING ON TIME

"The present passenger car, [the new train running between Petaluma and Santa Rosa], is . . . very comfortable and convenient, and runs on time, much to the astonishment of the natives who have so long been accustomed to irregular boats and more irregular stages [stage coaches]. At the [Santa Rosa] station we are met by the stage runners proclaiming their respective stage routes. The coaches are quickly loaded and off they go bowling over dusty roads to Sebastopol, Bodega, Bloomfield, Healdsburg, and Cloverdale . . . one of the results of the new railroad is seen in the enormous increase of travel in Sonoma County . . . "

MRS. BUTIN AND DEAR OLD LIZZIE

The automobile opened up a fascinating world of adventure for travelers in the first half of the 20th century. In the early days, roads were rough, narrow, and sometimes non-existent. Cars acted unpredictably, especially when called upon to climb mountains or operate in extreme weather conditions. Travelers recounted their tales, but perhaps none any better than Mrs. L.H. [Georgia] Butin, who, with her husband at the wheel, enjoyed many adventures in "dear old Lizzie," the nickname she gave their Ford Model-T. Her column appeared regularly in the Petaluma newspaper.

Mrs. Butin told of summer life on the Russian River and autumn camping on the coast. The Butins retreated to the river resort of Rio Nido in west Sonoma County in July 1924. For summer socializing, Rio Nido was the place to go in the 1920s. It attracted people from all over Sonoma County as well as many folks who came from the Bay Area to get away from the pressures of urban living. Here's her summer report on life along the Russian River:

A few miles west of Rio Nido, ocean lovers enjoyed sun, sand, and music. From left, Pete Canepa, Margaret Milne, Mabel Howard Matison, and Laura Matison got ready for a splash in the ocean while Tommy Francischi of Occidental serenaded them with his concertina. (Sonoma County History Society.)

All that was needed for a good outing c. 1916 was a supply of food and drink and a sturdy truck to carry revelers to Dillon's Beach or the Russian River. The truck, perhaps a Reo or Autocar built around 1910, left in the morning from Oak Hill Park in Petaluma and made the return trip the same evening. The solid wheels with hard rubber tires did not make for a particularly pleasant ride. (Torliatt Family Collection.)

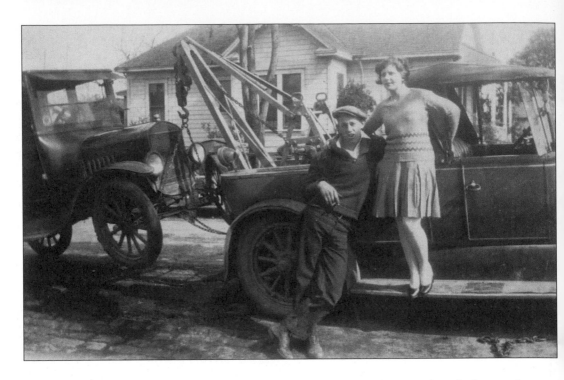

ABOVE: *Georgia Butin enjoyed her rides in "Dear Old Lizzie," even though the roads were rough, cars performed erratically, and it was sometimes tough getting from one place to another without a breakdown. When "Lizzie" broke down, a tow-truck driver was usually available to help haul her off for repairs. When a 1923 Model-T Ford broke down, a Dodge tow-truck with fancy round door handles was called to haul her away. Sam Winters was the tow-truck driver. The lady on the running board was not identified.*

OPPOSITE TOP: *Taxis came to Sonoma County by the 1910s. One of the early enterprising cabbies was Alden Stewart, showing off his vehicle on Bassett Street in Petaluma. His 1915 Ford taxi with a V-shaped radiator was "nickel plated" and "electrically lighted and started." A sign on the windshield noted the vehicle "In Transit." Stewart's stand was located at the John D. Hinshaw Cigar Store on Western Avenue . (Torliatt Family Collection.)*

OPPOSITE BOTTOM: *The advent of the auto gave young men a chance to demonstrate their racing abilities. John (Jack) Marra showed off his brother's cut down hot rod on Main Street in Occidental, probably in the 1920s. (Sonoma County Historical Society.)*

"Rio Nido is a populous city. It is filled with a vast throng of boys and girls from 1 to 70 who are seeking a good time and a surcease from their work-a-day cares. And they're getting it.

"There's box ball, swimming, dancing, and multitudinous other activities to engage the time and interest of the more active, and then there's the 'just sit and talk' and 'look-on' method of passing the time for those who have sought the inhabited wilds for a rest, physical and mental . . .

"The swimming is excellent. At the Rio Nido beach a tobaggin slide has been erected that furnishes the thrill that the enthusiastic bather is constantly looking for. Johnson's Beach has a slide for the kiddies, a diving platform, numerous buoys, and a fine beach.

"The dancing pavilion is the center of attraction every evening, beginning at 8:30 and continuing until a late hour. An orchestra of nine pieces supplies the best of the latest dance music.

"How to get there is the all important question these days.

"The announcement that the road from Sebastopol to Molino is open with a new paved surface might tempt some to go by that road. Don't do it. As far as Molino the road is as fine as you can get anywhere, but thereafter, in plain English, it's rotten. Dust and chuck holes, hard, rocky bumps—in fact, all the torments of a road that has been long neglected, and badly used in the bargain, await you."

A CAMPING TRIP TO THE COAST

Mrs. Butin showed a visiting friend from Washington around Sonoma County in autumn 1924. After visiting Luther Burbank's home, taking in the redwoods at Armstrong Grove, and seeing many other sights, the Butins took their friend on a camping trip to the coast.

"We packed dear old 'Lizzie," prepared to stay a day or two and left home. We drove to Bodega . . . and then straight up the coast and enjoyed every minute of the day . . .

"The camp site [near Jenner-by-the-Sea] was selected and we established ourselves in a cozy nook . . .

"On Friday, as we were returning to camp from a short stroll, we stopped at the store to chat with the storekeeper and he told Mr. Butin that he was going to Duncan's Mill in his large motor boat in half an hour and would be glad to have us go along . . . we ate a hurried lunch and hastened down to the landing. There were 11 of us altogether who took the trip. The river was quite rough, but not enough to be at all unpleasant going up. It was all so beautiful—the wide, green river, the bare, rolling hills on one side and the tree-clad cliffs on the other, and the boat gliding swiftly along between.

"Going back, we cut across the waves in such a way that every few minutes one a little bigger than the rest would come all over the boat. The men were holding a big canvas up in front and whenever a wave came on board, everyone ducked and yelled, but, in spite of all precautions, everyone got more or less wet, which added greatly to the hilarity of the company. When we got back to the landing everyone was breathless with laughter.

"Saturday our neighboring camper went surf fishing and that evening everyone enjoyed a nice mess of fish, for he was . . . generous in dividing with his neighbors.

"[When it started to rain the next morning] we moved our cooking paraphernalia into a shed near by and laughed and let it rain . . .

"Monday morning, Mr. Butin began to work at 'Lizzie' trying to persuade her to start home. While he was doing this our tent and auto cover were drying nicely. Our . . . friend helped us all he could and towed her around but she wouldn't start. So, while we got lunch, Mr. Butin made a fire in the heater and dried out the coils thoroughly and after lunch she started without any trouble.

"Our [Washington] friend says she never saw a country where there is so much pretty scenery and such a variety of places to see as in Sonoma County."

When wedding bells rang for Peter Torliatt Jr. and Bernice Stewart in 1918, family members prepared for the event by decorating their car with branches. The Ford Model-T roadster with a brass radiator had a top speed of perhaps 25 miles per hour, an impressive figure at the time. (Torliatt Family Collection.)

OTHER ADVENTURES IN THE AUTO

MARIA SNIDER GOSSAGE

" [M]y brother] Walter had a truck, and one day it wouldn't start. He decided to tow it and asked Mama to give him a hand. He told her all she had to do was step on the brakes when he signaled. All was going well until the tow rope broke. Walter hollered for Mama to put on the brakes. As the truck continued to roll down the hill, Walter saw Mama looking under the dashboard for the brakes. To make a long truck story short, it went on down the hill and crashed into the barn. Mama and Walter survived but the truck and the barn had 'Big Troubles.'"

CARROLL REINERS

" John [Reiners] had the first automobile on Dry Creek [near Healdsburg], a single cylinder Reo. He kept it about a year and then

sold it for two cords of wood and bought a two-cylinder. Dad's driving was normal but on his arrival at the ranch he drove right through the back end of the shed where he used to keep the single-cylinder Reo."

BARNEY BARNARD

"When I was 18, 19, 20, we went to Guerneville in the summer. City people would come up, and the girls liked to dance with country boys! I had cousins my age in Oakland, and I'd go down there. We used to go up to the dime dance halls; you'd give a girl a dime and she'd teach you all the latest steps. I got halfway good at it. And I met my wife in Forestville. There used to be an electric car—streetcar—that came to Forestville. She came up with her sister and two of her cousins . . . She could dance good. She had a way of

holding herself on the floor—outstanding.

"I had the car, see . . . I'd take four or five guys from town here and we'd go to old Mirabel or Guernewood Park. A lot of boys didn't have a car in them days and I'd take them. We liked Guerneville."

A MUSICAL CRUISE

As the Butins and others motored through the West, teenage musician and band leader Leroy Jewett dreamed of international adventures. By the time he was 16, Jewett, who played the xylophone and drums, was an established performer on Redwood Empire bandstands. He played events ranging from junior high school dances to parties for business leaders at upscale country clubs.

Travel by luxury liner was becoming a way to see the world, especially for talented

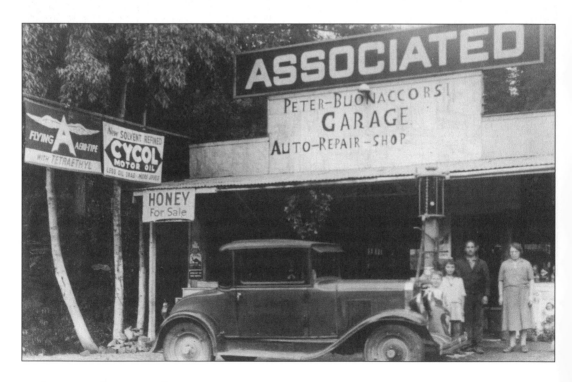

With cars and motorcycles came gas stations. Pete Buonaccorsi's garage outside Occidental offered gasoline, oil, and honey. That's a 1930 Buick in front of the station. (Sonoma County Historical Society.)

Peter Torliatt displayed the latest in fine motorcycles, an Eagle brand bike that was popular with the younger set in the 1920s, and cheaper than owning a car. (Torliatt Family Collection.)

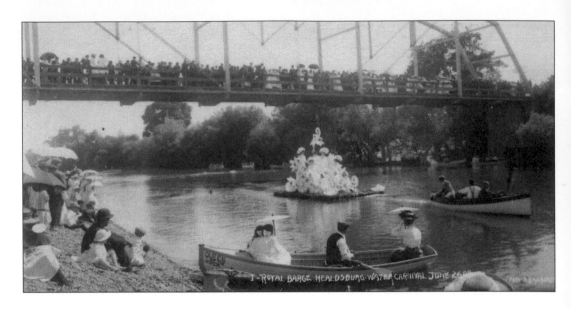

Advent of the automobile made it possible for large numbers of people to travel to such events as the Healdsburg Water Carnival. At one such event early in the 20th century, crowds gathered on shore and atop the Healdsburg Bridge to watch the Royal Barge float under the span. (Healdsburg Museum.)

Many sportsmen from Sonoma County took their summer vacation on the Klamath River north of Eureka. The giant bridge opened up the area to an increasing number of tourists and salmon-steelhead fishermen in the 1920s. Don (left) and Ken Torliatt rowed their mother Bernice for a look at the new span. (Torliatt Family Collection.)

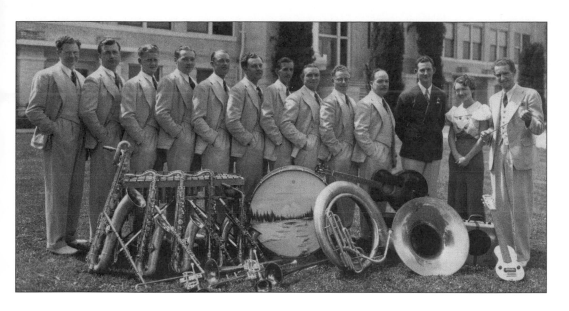

In the era of Big Bands, the Jewett Band was popular in Sonoma and Marin counties through the 1930s. The band played at outdoor concerts at the Russian River and in Marin County. Members included, from left: Louie Hamilton, unknown, Ed Gundstrom, Walt Oster, Walt Hobbie, Al De Martini, Bill Hyer, Vic La Franchi, "Peewee" Leiton, Ernie Layton, Les Winslow, singer Melba Lewis, and Leroy Jewett. (Torliatt Family Collection.)

Armand Reed was one of the "clean, stalwart boys" who took the Orient trip in 1927 with the Jewett combo.

It was the cruise of a lifetime for Leroy Jewett and his combo when they were chosen to perform on a Dollar Lines cruise in 1927. Dressing up in shipboard attire prior to the trip were Alvin Agnew and Jewett. (Torliatt Family Collection.)

young musicians. While other young people were getting ready for final exams and planning their futures in Sonoma County, Jewett was packing his bags for the adventure of a lifetime: a cruise to the Orient on an ocean liner. It happened when Jewett and his talented musical combo were selected to serenade passengers on a Dollar Lines cruise in 1927.

The band won its two-month dream trip on the steamship *President Jefferson*, beating out 250 other orchestras that applied. Jewett was joined by fellow musicians Walter Hobbie, Arthur Foster, and Armand Reed, all characterized as "clean, stalwart boys." First port of call was Hawaii [not yet a state], followed by the Philippines, Japan, China, and Hong Kong.

The boys sent frequent letters home with their impressions of the trip.

FROM HAWAII:

"We are busy working dances several times a day. Here in Hawaii, we like the warm water and beaches and the homes are really fancy. The natives of the island are very much Americanized and mingle with whites as though they are of one race . . . it was a thrill to cross the international dateline; we went to bed Monday night and got up Wednesday morning."

FROM YOKOHAMA, JAPAN:

"We passed hundreds of small native fishing craft in Tokyo Bay. We saw that some Japanese forts had sunk under the bay or fallen to ruin after an earthquake earlier this year . . . We passed hundreds of small native fishing craft . . . Here in Yokohama [where they landed] the streets are unpaved and extremely narrow."

FROM KOBE JAPAN:

"The kimonos are colorful and we saw young women carrying babies on their backs. The music sounds like a mix of tin pans, fifes, one-string fiddles, pig squeals, and the howling and groaning of a man in agony. The Japanese [wooden] sandals also make a kind of musical clatter."

FROM SHANGHAI, CHINA:

"Shanghai is peaceful but soldiers of America, England, Spain, France, and Japan are on patrol. There are barbed wire entanglements and machine guns and a lot of poverty. The river is literally covered with Chinese junks, occupied by poor families. Their clothes are a mass of filthy rags and sacks; in fact, there were a number of families dining on garbage thrown from our ship.

"The street peddlers sell their wares by singing as loud as possible. Beggars are everywhere; they live in absolute filth, some of them with fingers or hands eaten off by horrible disease. We were constantly being bumped on 4-foot width sidewalks traversed by hundreds of [natives] . . . [Alluding to odors] we could have found a most wonderful use for clothespins whenever nearing a...delicatessen store.

"We got a kick out of the Chinese music but after a while it drove us almost crazy."

In late May, the Sonoma County youngsters docked back in the Bay Area, just in time for graduation ceremonies.

CHAPTER 7

The Master Propagandist

*Wife Leona, daughter Herleon, and Bert Kerrigan (the three center figures) join other
Petalumans to serve 'em sunny-side-up, all in the name of promoting the sale of chickens
and eggs.*

David Wharff brought chickens to Sonoma County, a Canadian-born inventor named Lyman Byce provided technical breakthroughs, but it took a propaganda whiz like H.W. (Bert) Kerrigan to put the Leghorn in the limelight and bring the town international attention. When Petaluma was the "World's Egg Basket," chickens were a part of everyone's lives, in town or on nearby farms. If anything was sacred in Petaluma, it was the chicken.

Wharff came to Sonoma County with a coop full of chickens in the early 1850s, and in 1878 Canadian-born Lyman Byce opened the Petaluma Incubator Company. His incubator allowed large numbers of baby chicks to be hatched artificially. Petaluma was able to ship its growing supply of eggs efficiently via the Petaluma River. Still, businessmen were concerned about their inability to attract new industry into town.

At the end of World War I, the Chamber hired Kerrigan, who had gained fame as a high-jumper in the 1906 Olympic Games in Athens, Greece. Kerrigan was a public relations genius of Olympian proportions who decided to put all his money on eggs. With $50,000 from the Chamber, Kerrigan hoped to induce consumers to eat more eggs and ranchers to settle in Petaluma.

Kerrigan planned the first National Egg Day in Petaluma in 1918, featuring crowds dressed in yoke yellow and egg white, and an Egg Queen with a court of attendant chicks. Under Kerrigan's skilled direction the events became more elaborate and zanier each year, reaching their peak in 1921 and 1922.

H.W. (Bert) Kerrigan, an Olympic high jumper and extraordinary propagandist, created the Egg Basket as Petaluma's symbol in the early 1920s. Although he was only 5-feet, 4-inches tall, Kerrigan competed in the high jump, crossing the bar at 6 feet, 2 inches— more than 10 inches above his own height. Kerrigan retained his athletic ability in later life. As he neared age 50, he demonstrated his skills on numerous occasions. Once, he vaulted over a horse 15 hands high and another time he jumped over a 3 1/2-foot-high chair. The Kerrigan photos are from the Petaluma Museum Collection.

THE EGG DAY WEDDING

"A novel stunt is being worked up by H.W. Kerrigan as a feature of Egg Day; in the nature of an Egg Day wedding to take place publicly at a place designated, a prize to be offered the couple and the merchants to present gifts to the bride . . . This is not a joke. No 'chicken' wedding is intended, but a real wedding with egg decorations, chickens for the bridal feast, and everything to be in accord with Egg Day.

"Miss Lena Spaich and T. Murray Gow . . . were quietly married this morning . . . by Rev. Father J. Kiley at the Spaich home after which at the Hill Plaza they were accorded a

public reception in honor of the Egg Day marriage . . . the bridal banquet was held and the menu consisted of special egg dishes, from recipes contributed by Chef Victor of the St. Francis . . . just relatives of the bride and groom and attendants of the [Egg Day] queen were present at the [head] table.

"A coop of chickens were let loose in the same space with the party and the cook's utensils were in an opposite corner, and the camera men were very busy taking pictures of the bride and groom and attendants, and Queen Marjorie and the chickens.

"The Illuminated parade . . . came perilously close to ending in a sad tragedy when Gus Thulin . . . who was driving the beautiful truck of the bank's, was overcome by gasoline fumes from the engine. This float, the last in line, was approaching Dreamland Rink . . . Thulin felt himself going and tried to stick it out and for a time was driving blindly, guided by little Miss [Jeanette] Turner [who sat on a perch over the concealed driver's seat].

"Just before the collision, she cried, 'turn to the right' but Thulin feebly replied, 'I can't,' then came the bump [when they hit a parked vehicle] and he jammed on the brakes in a last, desperate effort and collapsed."

" . . . Jeanette Turner was heard to cry, 'Let me down.' Leo V. Korbel, who was standing nearby . . . hastily lifted the hysterical girl to the ground and springing into the float, tore away the egg [that fit over the trap door covering the driver's seat] and with the help of another man, lifted out the unconscious driver. [Thulin recovered.]"

Even traveling stage performances were shaped to promote Petaluma's Eggomania. When the "Marcus Revue of 1921" came to town, performers personalized their vaudeville performance with a number of "diversions."

"The first diversion came in the first act when a small edition of the World's Egg Basket . . . filled with . . . baby chicks was sent over the footlights by the Chamber of Commerce . . . The second was . . . when the

Kerrigan's favorite fan was his daughter Herleon who was happy to help her father with his efforts to sell "Chickaluma."

company was 'egged.' Not like the ordinary 'egging' party, for another World's Egg Basket . . . the basket filled with Petaluma whites was sent over the footlights . . . Just about that time, Al Herman(n), the 'human rooster,' who had been stationed behind the wings, began his deadly work and emitted

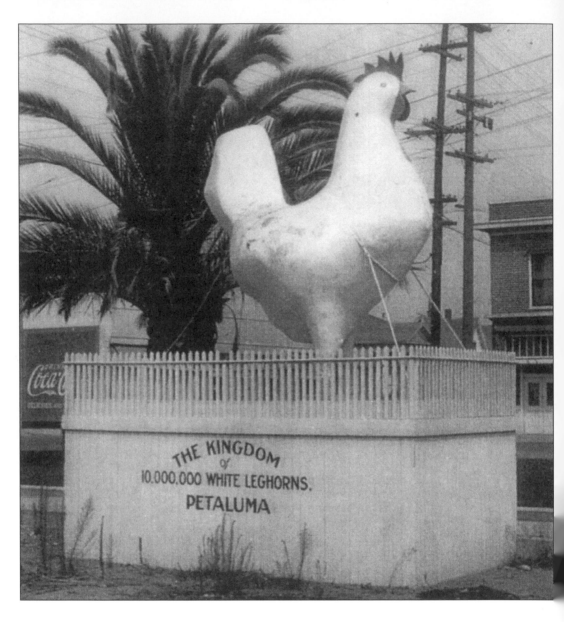

The mighty Leghorn stood tall first at the train depot in Petaluma and later at the south entrance to town. It became a frequent target of attacks by youngsters from nearby communities, such as Santa Rosa and San Rafael.

crows of all kinds, sizes, pitches, and qualities from an undersized bantam to a full edition Plymouth Rock and he rocked the sides of the performers, some of them laughing so they could not speak. A rooster had broken up a chicken show, as has happened before in the best of families."

THE HUMAN ROOSTER

Al Hermann, a contractor by day and "human rooster" by night, had become Kerrigan's vocal propaganda weapon. The Hermann legend first came to the attention of readers of the Petaluma *Argus* in 1902

when he was 26. The headline read:

AL HERMANN A CHICKEN WIZARD
PECULIAR ACCOMPLISHMENTS OF A
YOUNG POULTRYMAN
TEACHES CHICKENS TO DO TRICKS,
ROOSTERS TO FIGHT AND CAN IMITATE TO
PERFECTION THE DIFFERENT VOICES IN A
POULTRY YARD

"Al Herman[n] is a popular young man of Penngrove who for a number of years has had charge of the several thousand fowls on the Wm. Evart ranch . . . He is an expert in his business and handles the birds different than any other poultryman in this vicinity . . . his flocks are in better condition, lay better, and escape disease more than the majority of flocks in this vicinity. Many of the birds have been given names to which they readily respond, and he has several trick chickens. He has taught one little hen half a dozen different tricks while two roosters on his place engage in a regular scrap at his command. When a stranger enters the poultry yards, the fowls all scamper away in fear but when Mr. Herman[n] appears they fly to him, surround him, and perch all over him in perfect contentment.

"But the strangest thing . . . is Mr. Herman[n]'s ability to imitate the crowing, cackling, and singing of the fowls. For nine years he has made a study of this and now can imitate the music of every kind of fowl on the place, from the gobbler to the duck and from the tiny bantam to the huge Brahma. He recently attended a masquerade and represented a huge rooster. His crowing was so natural that . . . he received a prize. When this chicken wizard goes hunting, he needs no decoys. His voice summons all the ducks that are within calling."

CHARLES TORLIATT JR. ON AL HERMANN

"Al Hermann came to our house [in East Petaluma in the 1920s] to do some repair work. I remember it was getting toward dusk, but it was a nice night, and he went to the backdoor. He stood near the screen and listened out the door for a little while. 'Want me to wake up a few roosters?' he asked. He started making clucking noises. The two Giacomini families lived near us and pretty soon all their chickens were clucking back. It was the first barnyard chorus any of us had ever seen in our neighborhood."

A NEW HOTEL

The success of Egg Day called for a modern hotel to handle the growing throngs of visitors. The result was the Hotel Petaluma at the corner of Kentucky and Washington Streets Kerrigan and community leaders made their fund-raising goal of $250,000 with a last-minute surge.

They were buoyed by a victory song, sung to the tune of "Battle Hymn of the Republic":

All in favor say I, I, I, I, I.
All in favor say I, I, I, I, I.
We'll build a hotel in this our town,
We'll make Petaluma go 'round and
'round,
All in favor say I, I, I, I, I.

CHICKEN CHATTER

With Egg Days nearing, Kerrigan was given an assistant, Capt. J.B. Young, who wrote a "Chicken Chatter" column, which gave poultry-oriented tips:

"Watch out for rats. A lady lost 100 chicks, a rat taking all of them."

"The hen that sings and digs away is contented and a good layer. Watch the hens that loaf, for the biggest job they have is eating up your grain."

"The little chick, he peeps and peeps, and don't know what's the matter. We know [he wants a feather bed to stop his little chatter.]"

"Cooties are just as unhealthful in the hen house as they were in the trenches. Put over a barrage of powder, keep the hen house clean.

The Petaluma Minstrels, popular entertainers in the 1930s, included, back row, from left, Esther Parmeter, Ray Hofsteder, Roscoe Evans, Al Hermann and Sylvio Volpi; (front) George Ott, Edith Guthrie, Ralph Cochrane, Ben Badger, unknown, and Arthur Evans. Hermann, the "Human Rooster," gained fame for his ability to mimic the sounds of almost two-dozen types of chickens. He became a noisy part of Kerrigan's Egg Day promotions. (Petaluma Museum.)

"Hard-working men must always eat. A lazy hen makes a dandy meat."

Kerrigan had already found a champion crower in Penngrove's Al Hermann, but he had to reach out to Lamar, Missouri, for a champion egg-eater. A young man named Logan Rector "managed to put away 6 dozen raw eggs in 20 minutes and won himself a wager of $5" and an invitation to Egg Day, 1922.

HAIL TO THE QUEEN

The Egg Queen title went to Clarksville, Tennessee beauty Martha King. Martha won a free trip, with escort, to and from Petaluma.

J. Chris Partsch, employed by an egg exporting firm, wrote a poem to honor Queen Martha:

Welcome to the Queen of Clarksville,
Tennessee
Miss Martha King, welcome to thee.
You have been chose Queen of Petaluma.
In Golden Northern California.
For we sure expect to meet you.
And we'll all gladly greet you.
For you will rule us while you stay,
And gladly, we will all obey.
So all glad people come to our country town
In glad rags, and leave behind your daily
frown
Just stop over when you are out for a run;
Just stay a while, and have a little fun.
Just you come if you love chickens,
Providing you can catch 'em in the town of
Petaluma,
In the County of Sonoma.

Kerrigan's publicity plans included direct assaults on the City of San Francisco with girls, boys, chicks, and feathers.

"Al Herman[n], the great Petaluma booster, accompanied by a bevy of fair Egg Day girls and a flock of stalwart youths, all garbed in regulation style [costumes of yolk yellow and egg-white white], departed . . . for San Francisco where they did their stuff at Powell and Market streets at the magic hour of noon . . . a delegation of fair Petaluma maids and stalwart high school youths [were] in charge of 50 live young chicks . . . the crowd was so dense that it blocked traffic for 15 minutes . . . five motion picture cameras were on the job . . . While the chicks were being turned loose by the girls, Herman[n] started to crow and he crowed so long and so loud that the crowd for a time . . . looked around in vain for the big, husky rooster who was making all the noise." It was a great idea and it originated in the fertile mind of H. W. Kerrigan.

Meanwhile, Clara Ivancovich, a "talented club woman," offered up a musical play called *Princess Petaluma*.

"The play will be given under the auspices of the Chamber of Commerce. The theme of *Princess Petaluma* shows the difference in the east and the west and tells of the wealth, the glorious climate, and the many advantages of the west, as compared to the east. It tells why California is the land of sunshine, flowers, and prosperity and why Petaluma, where the poultry thrive, is the known poultry center of the world . . . song titles include: 'Forest of Kale,' 'Chicken Dance,' and 'Chicks Catch an Angle Worm.'"

For a short while, Bert Kerrigan basked in the glow of Petaluma's success, but his days of glory ended in 1924 when he resigned as chamber manager.

ED FRATINI ON KERRIGAN

"[The Chamber] ran out of money. These Egg Day affairs . . . grew out of proportion . . . To pay the bills it was necessary to assess the [Chamber] members' three years' dues. Well, you can imagine the results. The scapegoat was Kerrigan."

Petaluma held a scaled-down Egg Day dinner-dance in September 1924.

THE LAST WORD

Perhaps the most unique view of the chicken industry was provided by an unnamed youth who had a feel for eggs, if not a high level of grammatical skills. This is the essay, printed in the Santa Rosa *Republican*, of a boy who was told by his teacher to write a composition on eggs.

"Every bird used to be a egg, especially chickins. When you eat a chickin you don't generally stop to think how it would look if its mother had sat on it all she wanted to. If you hold a hole raw egg in your hand it will jest stay there perfeckly still, but if you suddinly all of a suddin crack it in half it will do jest the opposite.

"Hens lay eggs jest for the plezzure to think how mutch enjoyment sumbody will get out of it at breakfast. Wen a hen lays a egg it goes erround caceling as if it had jest did sumthing that hardly enybody else could do,

wich it has. Roosters can't lay eggs and proberly don't want to.

"By jest looking at a egg before it is hatched you cant tell wether the chickin will grow up to be a hen or a rooster, and after it is hatched you cant even tell by jest looking at the chickin. This proves that nature is misterious.

"The most popular time for eggs is brekfist, people eating either one or two, depending on how ixpensive they are. Eggs look prettiest fried and most natural soft boiled and most unnatural scrambled."

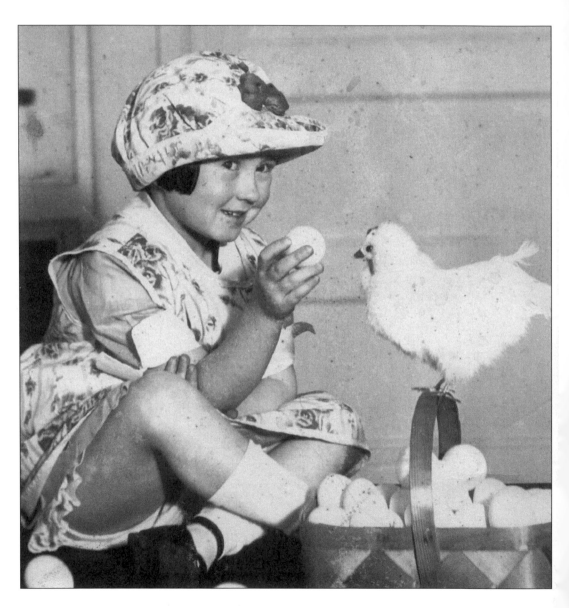

Which came first, the chicken or the egg? Herleon Kerrigan, about 5 years old, wasn't quite sure but she was sure that she was happy to help her dad sell Petaluma to the world.

CHAPTER 8

War

International tensions had an impact on Sonoma County as early as 1916. A Sonoma County unit, Co. K of the National Guard, was sent south to deal with border tensions with Mexico in 1916. Stationed in Nogales for several months, the unit returned home in October. Members of the group, including Charles Torliatt Sr. (right), engaged in horseplay during a training session while another soldier watched. (Torliatt Family Collection.)

Many Americans prided themselves on avoiding foreign entanglements but in 1898, the United States emerged on the world scene when it won a quick victory in the Spanish-American War. In World War I, American troops helped turn the tide in favor of the Western Allies, and emerged as the world's dominant power after defeating the Nazi menace in World War II. Behind the headlines, there were dramatic stories of people who took part in these conflicts.

SINKING OF THE TUSCANIA, 1918

The *Tuscania* was the first troopship sunk in World War I while carrying Americans overseas. On the evening of Feb. 5, 1918, off the coast of Ireland and only hours away from a safe landing in Liverpool, England, the British transport *Tuscania* was targeted by three torpedoes fired by the German submarine *UB-77*. One buried itself between the engine room and the stoke hole and exploded at 6:45 p.m.

The ship, carrying 2,179 members of the American Expeditionary Forces to England to fight in World War I, stayed afloat in the chilling waters of the North Channel for nearly three hours before it sank. The following day, 310 men, mostly American soldiers and members of the ship's crew, were reported dead or missing. Many had died when their life boats crashed on the rocky shores of Scotland. Those who survived were either picked up by other ships or drifted toward the less perilous shores of Ireland.

Among the survivors were an officer and an enlisted man from Sonoma County, Lieutenant E. Denman McNear, scion of the George P. McNear hay and grain empire, and Private Alden Stewart, an enlisted man who joined the U.S. Army a few days before the draft went into effect in December 1917. There were substantial differences in the backgrounds of the two men. McNear was born at the family mansion at the south end of town and received the kind of education one would expect for one of Sonoma County's leading families. He attended University of California from 1904 to 1908, and when World War I came along, served as a lieutenant.

Stewart was born in Petaluma March 29

Denman McNear, scion of a wealthy Sonoma County family, survived to tell the dramatic story of the sinking of the troopship Tuscania *in February 1918. More than 300 men lost their lives when a German submarine sank the ship. McNear returned to Sonoma County to take an executive position with the G.P. McNear Feed Co. Photo in 1936 shows, front row, from left: George P. McNear, Denman McNear, and L.V. Korbel; (second row), Thomas Bryan, A.E. Campigli, and C.M. Harms; (top row) John Gonsalves, Egidio Martini, Alberto Bottini, and Joe Nunes. (Petaluma Museum.)*

1896, the second of three children of William A. Stewart and Elizabeth Hickey Stewart. He worked as a clerk for Hickey and Vonsen as a youngster and while still in his teens set up a taxicab service, operating two vehicles, one at Hinshaw Cigar Store and another at the Continental Hotel. His 1915 Ford was described as "about the swellest thing in its line ever put into service here." It was electrically lighted and started, was nickel-plated and had a V-shaped radiator. He moved to Alaska to work as a "bucker and faller," then enlisted in the U.S. Army Dec. 8, 1917.

The *Tuscania* left Hoboken, N.J., as part of a 20-ship convoy. On the stormy night of the attack, the troops on the ship were in a good mood. After a rough voyage, they had sighted land off Ulster, Northern Ireland, and were anticipating coming into harbor the next day. As one survivor, Herbert A. Gustafson, wrote, "We were safe now, we thought, and the next morning we expected to arrive in the harbor of Liverpool." Instead, the *Tuscania* went down with great loss of life.

DENMAN McNEAR

McNear's letter gave a graphic picture of life on the sinking ship:

"We had been out so long—nearly two weeks—and finally sighted land, followed by land on both sides, and with port the next morning things seemed surer than ever before—and too, darkness was falling. We were well protected . . . and no convoy had ever been attacked and a troop ship sunk, except in the Mediterranean . . . I was sitting as much absorbed as I am right now, when all of a sudden there was an explosion, and immediately darkness, my thought was that it had really happened."

McNear groped in darkness to return to his stateroom to pick up two items, his long underwear and a Brooks Brothers suit which 'had always been kept right in front of the door under the wash basin." When he got to

his assigned lifeboat he, "learned that No. 9 had been lifted from the position opposite the deck where it hung in its davits . . . to the boat deck by the forces of the explosion and it landed on the boat deck in such a manner that no amount of work could budge it, and [boats] 9a, 9b, and 9c were very successfully and completely blocked behind it . . . Where can you find greater courage that those fine men [on deck] showed—who, knowing that their life boats would never come—stood there in ranks, in order, on that sinking ship. There was no panic, as was expected from the untrained troops, many of whom were sent to cut lumber . . . one or two boats were lowered and filled successfully from the 11 station. The other men watched these men row away in good order."

The lieutenant worked his way to the boat deck with his roommate, whose name was Pattison. "I knew I had no place in a boat. Every man was assigned, and I was not going to try to get another man's place, so I thought to get up on the Boat Deck—see what progress was being made—and also be in a position to float off when she went down. I had learned from one of experience that a big ship sinking slowly had no suction to speak of, and . . . I was going to hope to be picked up out of the water."

McNear watched while many of the men climbed aboard one of two destroyers or onto lifeboats that were not damaged. Then he realized there was room for him in the last, crowded lifeboat.

"When we got all the men in who kept coming down the ropes, we had maybe 60 men—just jammed in—no room to move. A man signalled [sic] us who was in the water and we picked him up. We then called to see if there was anyone left aboard. Lo and behold! There appeared Lt. Pattison, my room-mate whom I had left hours ago—before either destroyer came even . . . we got along side and he soon came down a rope—another man was picked up in the water and then started a fierce hour's work.

"The captain sent up some enormous rockets . . . it was these that brought the

second destroyer at 35 miles per hour. It was the second destroyer that helped me in my many difficulties, for it was she that took off so man many men that . . . there was room in this last lifeboat for me. The first destroyer had taken a couple or three hundred [survivors] . . . This second one filled up inside, then she began covering her decks. [It was probably on this second destroyer that Stewart, one of the last men to leave the ship, ended up.] Finally, the captain had all he could hold up—but there was a stream he did not want to shut off, so that splendid man and capable sailor started pumping oil overboard, and in all he pumped over forty barrels. It took a fine bit of seamanship and daring for him to come along-side and lay there . . . when he pulled off it was a wonderful sight. That low ship with her decks a mass of humanity."

The ship with its overload of 600 men faced more danger from the German U-boat, which fired a torpedo at the overloaded destroyer. It missed by no more than 2 to 6 feet.

"Had that torpedo struck as the one at 6 p.m. did, nearly all of those men would have been lost, for the destroyer had few or no life boats, and we could have never gotten off in our boat. What that destroyer's daring, and that torpedo's missing, had to do with me! My, but these British have earned their laurels on the sea."

Then began the effort to get to safety in the lifeboat.

" . . . Once in the boat began a painful hour. We wanted to get away from the ship, we were leaking, we were so crowded we could scarcely row, and had no oarsmen . . . I got a long oar and put it out astern through a lock—and with [Lieutenant] Thall coaching the absolutely green oarsmen—and an assistant and myself working this long oar—we tried to get away from the boat, and also keep headed up so the waves would not come over our sides. We would get her straight and start to row ahead and she would swing right around into the troughs again [due to the wind and the boat being heavy with water and men], and we would ship water . . . Our struggles with the oars were so nerve-racking and futile, the water was gaining, wind and sea rising, that we finally gave up rowing, and got additional men to bail with hats . . . Finally, about an hour after we had put off, and before we stopped rowing, the *Tuscania* began to sink faster and in a minute or two the little of her that was left above water had been submerged."

The people in McNear's lifeboat made an unsuccessful attempt to transfer some men from the overcrowded craft to another boat, but the "jagged end [of the other vessel] jabbed a hole or two into our canvass top sides . . . the water poured in through the new holes.

"It was almost impossible to describe those hours in the boat—energy exerted in getting the men to bail, and bail faster. Finally, all the woodwork was under water and the sea high and wind fierce. We were drifting north and out through the channel into the ocean . . . we saw a new red light. Then we lost it. After a while it reappeared and we really thought it was growing closer. We wasted both our flashes on this good prospect. Finally all doubt was removed—and there was a trawler—the captain giving us instructions to throw all oars away, and be still—catch a line and make it fast. The sea was a big one and you might wonder how we were transferred, but these fine Britishers had that all figured out. They lined the side of the trawler with husky seamen in big rubber coats and hats, with open arms. As the seas would toss our boat up and down, these men would grab men from our boat, when we were on a crest, and haul them into the trawler. "

"We learned that this trawler had picked up six boats ahead of us . . . we were all mighty thankful that he did keep on till so late. It is he that the *New York Times* mentioned as picking up 340 men . . . we were given up a cup of tea and made as comfortable as possible . . . when 6 o 'clock (a.m.) finally came and we were tied up to the wharf in Larne, Ireland . . . a mighty thankful lot."

ALDEN STEWART

In a letter to his mother, Pvt. Alden Stewart said, "I was below deck when it happened and the crash lurched us all down, and there was an explosion . . . there was a grand rush for the deck and then we all lined up from the life boats . . . we were the last company off the boat and picked up by a destroyer . . . We were landed in northern Ireland at 3 in the morning . . . we were treated royally . . . there are about forty of our company missing so far. I am well but lost everything, except what I had on my back, but we are getting equipped with necessaries . . ."

Some 1,900 men survived the *Tuscania* tragedy.

SITTING ON A SEA OF GASOLINE

The Drees family can claim roots in Sonoma County back to the mid-19th century. Alvin Drees, the son of the Petaluma postmaster, had a major adventure at sea in 1918. In a letter to his parents in December 1918, he told the story of "sitting on a sea of gasoline" on his hard-luck ship, the *Ophir*.

ALVIN DREES

"We played in hard luck ever since we boarded this ship, and now we are homeward bound on the Japanese liner, *Arva Maru*.

"Just before we reached the Straights [*sic*] of Gibraltar, we separated [from a couple of other ships], having received warning that the subs were in the straits. Some little British boats convoyed us in, but I will always say we ran the straits alone . . . This was our 5th day at sea, and when we sighted the Rock of Gibraltar, it sure was welcome . . . "

After a stop at Gibraltar, the ship left for Versailles, France, but a fire in the forward hold forced them back to Gibraltar. "I was one of the bunch ordered below to find the

Alden Stewart was on the Tuscania *the night it was torpedoed. It took dramatic rescue efforts to save Stewart and other men aboard the ship. After the war, Stewart worked as a policeman in Detroit before returning to Sonoma County in the 1930s. (Torliatt Family Collection.)*

fire," but when the smoke got heavy, the captain ordered the crew out and sent for fire tugs. Just after they closed the hatch, "there was an explosion that blew the whole top off the hatch. It's a miracle we were not all killed."

" . . . Our cargo was mostly gasoline. Gun crews were ordered into magazines to get ammunition out, and believe me it was ticklish work when you expect to be blown up most any minute. We were beached and it looked as though we had the fire under control, so most of us turned in and were sleeping soundly because we were pretty

tired. At 3 a.m., I heard the call 'All hands on deck,' and I started to dress in a hurry. Was about half dressed when I heard the call, 'All hands abandon ship.' I . . . grabbed what I could and got on deck. Tugs were alongside to take us off. All the forward part of the ship was now on fire, and we expected her to blow up any minute. Took us all to a warship where we were mustered, and found two men missing. We were sure refugees; some had only the clothes on their backs. I would have had all mine if somebody hadn't shoved my suit case overboard . . . [At the time of these troubles] we were about a mile from land, and when we sent our distress signals, the darn fools [on shore or on other ships] would send up more rockets. They thought we were celebrating, as this was the day of the signing of the Armistice . . . Sitting on a couple of thousand drums of gasoline, with a fire raging all around [us] is far from a pleasant experience."

Continuing explosions destroyed the ship, leaving Drees with a limited supply of clothing and no money. The survivors were transferred to a barracks and then were shipped home on a Japanese liner.

THE FLU EPIDEMIC OF 1918

War was not the only scourge in 1918. World War I ended in November but the Spanish flu, carried home by soldiers to Sonoma County and many parts of the world, stayed on and took a heavy toll of life.

World War I took a heavy toll on American lives abroad, but the war came home with vengeance when soldiers returned carrying the deadly Spanish flu bug. Many lives were lo and extraordinary measures were taken to protect the population. The McNear Co. office sta protected itself by donning masks during the 1918 flu epidemic. (Sonoma County Library.)

Wherever large groups of people gathered, such as military camps, orphanages, and schools, the danger was greatest. In October 1918, the disease swept through the army's Camp Sherman in Ohio. In 27 hours, there were 136 deaths from pneumonia, a rate of about 5 every hour.

By that time, the flu was also spreading through Sonoma County. Some 160 children were infected at the Lytton Orphanage north of Healdsburg. In November, hospital officials counted 24 flu deaths at Sonoma State Hospital for the disabled between Santa Rosa and Sonoma. County officials urged residents to "wear a mask and save your life." Detailed instructions were given on the types of masks to use and how to use them.

Schools were closed and law enforcement officers ordered children of school age not to congregate on the streets or in parks and other public places. Children going on errands were to go directly to their destinations, make their purchases, and return home. The same applied to those moving between their homes and job sites. Redwood Empire residents recalled the dismal days of the flu epidemic.

EDNA FLOHR

"The flu hit rooming houses where men who were down on their luck often gathered. Most people were afraid to go near the rooming houses for fear of catching the disease. My father, [police chief Mike Flohr], and a nurse who wasn't afraid ministered to the needs of the men and got them to hospitals for treatment."

LENA CERESA

"It was so bad, so many people died, we all had the flu, including my mother. She said I had it worst . . . when it hit me, I remember seeing things getting bigger, like snowballs . . . it was the fever."

Lena Ceresa survived the flu epidemic, although when she was stricken with fever "things [looked like] snowballs." (Torliatt Family Collection.)

Banker and historian Ed Fratini lived through the flu epidemic but his father-in-law was one of the fatalities. (Petaluma Library History Room.)

ED FRATINI

"We all had to wear masks, a gauze affair which was sprayed with Dobell solution, whatever that was . . . Everyone was supposed to wear these masks but it made for some funny sights, for instance a man riding a bicycle smoking a cigar or cigarette with the pulled up mask. And some of them were not kept clean . . . I worked for G.P. McNear at the time and we had an old teamster named Bob Malone. We had to make a delivery to a family that had the flu, so the boss said to send Bob, he was a bachelor, and he would not get it with that dirty mask he had on, and he never did get the bug."

Fratini's father-in-law was not so lucky; he died in the epidemic.

NORENE CAMPBELL

Attending University of California, Berkeley when the flu struck she and a friend volunteered at the Oakland Auditorium.

"It was full of cots and sick people with the flu . . . We wore those gauze [masks] over our noses and mouths, but didn't think too much about how much danger we might be in. We brought water to the patients who got jammed into the auditorium. I don't know how we didn't get it because many people were dying. What a crazy thing to do."

ANTOINETTE (TONI) KASOVICH

Mrs. Kasovich lived in San Francisco when the flu struck; she and her husband Tom moved to Petaluma in the 1920s.

"The whole family was sick, including my little sister who was only 16 months old. We didn't know where they took her because hospitals were full in San Francisco . . . My mother and father were sick in bed along with my older sisters and brothers. I was the only one up. A policeman wearing a mask came to the door one day and asked to talk to my

Norene Campbell, a student at UC Berkeley, helped treat flu victims at Oakland Auditorium.

Antoinette (Toni) Kasovich, a young girl growing up in San Francisco, lost a tiny sister in the flu epidemic of 1918. She and her parents survived. Toni and her father Lawrence Scopinich enjoyed a day at the beach, c. 1920. (Kasovich Family Collection.)

mother and father, who were both still sick. He went to the door of their room and told them that my little sister had died. My father wasn't working so we had to bury the baby in potter's field . . . Those were bad times."

CLOSING OF THE SCHOOLS

Father James Kiely, pastor of the St. Vincent's Catholic school in Petaluma, ordered his students onto home study in mid-January 1919. Children were told to pick up their books at different times of the day to avoid passing the illness to others. Petaluma's public schools closed again, and whole families were reported ill. In one family, the Bettinellis, it was estimated 16 to 18 people were afflicted at the same time.

"THE FLU MADE ME DO IT"

The most bizarre story of the flu epidemic involved a young man named Waldron H. Gardiner, who had the disease when he married Alice Gardiner in Santa Rosa on November 27, 1918. Less than a month later, he filed for annulment, saying, "[I was] out of my head at the time and didn't know what I was doing." He claimed the influenza made him temporarily insane, the fever rising to such a height that he went out and got married. The headline read: "Married In Haste and Now Repents."

THE DAY OF INFAMY: DECEMBER 7, 1941

It didn't matter much whether one was a soldier, sailor, or civilian. The December 7, 1941, Japanese attack on Pearl Harbor left indelible memories for those who watched Japanese fighter planes and bombers roar overhead.

Dick Steel, a sailor from Santa Rosa, ended up doing duty on the pier after his destroyer, the *USS Downes*, suffered major bomb damage in the Sunday morning attack.

Civilians Leo Bourke and Earle Bond thought they were watching military maneuvers, only to quickly learn that the raid was the real thing.

SEAMAN DICK STEEL

"God, I was so scared. They gave me a rifle and told me to patrol the dock [on the night of the attack]. I walked in the dark wearing just dungarees and a T-shirt. All my gear burned on the *Downes* when it was bombed. No hat . . . I don't think I even had socks on. It was hairy.

"Every once in awhile, you could hear guns going off. People were nervous and shot at almost anything. I'm sure Americans were shot by other Americans that night. [When six low-flying aircraft appeared] they must have been American planes because they had their running lights on . . . everybody on the island opened up on them and shot them down. I watched the planes go down . . . there was nothing I could do."

Two days later, Steel was transferred to the destroyer *USS Helm*, where he served the rest of the war.

Earle Bond, who later became a nightclub entertainer in Sonoma County, and Leo Bourke, a Sonoma County poultryman, watched the attack from residences on shore.

EARLE BOND

Bond, working in a department store in Honolulu, wrote home:

"That Sunday morning I was thrown from my bed by a bursting bomb which hit the mountain directly in back of our house. At first I thought it was Army maneuvers, but it finally dawned upon me that the sound was too close and too deafening to be a gun. By that time the radio was blasting. There is an attack in Honolulu by the Japanese! Stay off the streets! This is no joke! This is the real McCoy!

" . . . The house across the way had its

On December 7, 1941, Earle Bond was thrown out of bed when a Japanese bomb hit a mountain in back of his house. He escaped the Pearl Harbor attack without injury.

Leo Bourke, a Sonoma County businessman, watched people line up to buy bread after the Japanese attack on Pearl Harbor. (Petaluma Museum.)

kitchen torn to bits by shrapnel . . . We took the small portable radio and started up the side of the dense tropical mountain which is flush against the house and from its peak we saw before us the entire battle.

"By this time it was 11 o'clock and the attack was in full swing . . . At first the fear that gnawed at me sickened my stomach and I could hardly breathe. Then my heart froze with anger and hatred that covered up all feeling for safety . . . It made me want to curse . . . I swore at those swooping dive bombers and cursed with such violence I never knew could be within me.

"The shrapnel and the accompanying whistle it gives through the air was terrifying . . . Soon the attack was driven off and with the city burning in spots came the horrible realization that war had actually come to these peaceful Pacific islands."

LEO BOURKE

Bourke, who saw the attack from his garden, thought he was watching military maneuvers. Untroubled by the noisy display, he and his son went in the opposite direction on a fishing trip. Later, he was told the attack had been for real.

In the aftermath:

"All food shops were closed except bakeries, which were permitted to sell one loaf of bread to each person at 10¢ a loaf. Nearly every person in Honolulu was in line to buy his loaf of bread . . . At first there was almost a panic among the people to buy things, but after a few days this died down.

"There was also a run on the banks. Between $6 and $7 million had been withdrawn, and soon the banks would be forced to close. The military governor

ordered the money returned to the banks, under threat of prosecution of any person who was discovered with more than $200 in currency."

Steel, Bond, and Bourke escaped uninjured at Pearl Harbor but two Sonoma County servicemen—Rudy Theiller of Sebastopol and George Maybee of Santa Rosa—were both listed as missing after their warship was hit December 7.

THE DOCTOR AND THE ENEMY SOLDIER

Dr. Clement Stimson was a man who knew how to use his hands, whether working as a youth in a mill at McCloud, California, or later when he set up his medical practice in Sonoma County. During World War II, the doctor gained international attention when he saved a badly wounded Japanese soldier.

After he signed up with the Navy, Stimson, who tended to get seasick easily, was sent to the Aleutians where rough seas and bitterly cold weather were commonplace. The incident that brought him fame occurred when he was stationed in the sick bay on the navy supply ship *USS Spica* in 1943. During the battle for Attu, many wounded Americans were brought by launch to the *Spica* for emergency surgery.

On one trip, the launch arrived with an enemy soldier named Ito. Ito, according to witnesses, smelled badly as he arrived on a makeshift Japanese stretcher. As others grumbled, one gunner, looking down from his platform, shouted: "For Christ's sake, you dogfaces throw that bastard over the side before he suffocates us all." Days earlier, Ito had his leg shattered when a grenade went off in his foxhole. By the time he reached the ship, his leg was "a greenish, muddy, bloody mass of gas gangrene."

Ito later said that when he arrived aboard the ship he was terrified, presuming that the Americans had let him live merely so they could torture him before they killed him. While some GIs wanted Ito tossed overboard, medical personnel had other concerns. Should the supply of drugs and plasma be used on an enemy? Should the doctor and his aides risk the chance of infection from a patient with a case of gas gangrene?

DR. CLEMENT STIMSON

For Stimson, medical ethics won out over military considerations.

"I asked if there were any other American wounded who needed treatment. There weren't any. 'Then bring him in,' I told the medic. The corpsman gave Ito an injection, some plasma, and a spinal anesthesia. Then he strapped the soldier to the table. Then I amputated his leg. It took more than an hour."

AUTHOR WILLIAM BRADFORD HUIE

"Doc worked slowly, carefully, halting every few minutes for [an aide] McCroskey to douse his mask with solution to keep him from being overcome by the stench. He gave Ito the fanciest amputation in the medical books—the type in which a flap of flesh is fashioned and drawn over the end of the leg so that an artificial limb can be worn in comfort . . . As the crew wheeled [Ito] away, Stimson smiled and said, 'Take him away, boys. And get that leg over the side.' A crewman weighted the leg, walked out on deck, and heaved it overboard.

"At first, some Americans on the ship, wounded in the fighting against the Japanese, were miffed that the Japanese soldier had been saved, but Ito soon made friends, using mostly sign language to communicate. GIs provided him with Hershey bars, peanuts, and cigarettes."

BOB STIMSON

"When they decided to move the guy, he reached out from his cot,

"Doc Stimson charged $2.50 for office calls, $3 for home calls, and often nothing at all for those who could not pay the bill. One night, one of the local cops saw doc pushing a cart toward a run-down motel at the south end of town. He was on his way to visit a stranded family with sick kids who were living there. He took them a big basket of food."

THE REDWOOD EMPIRE AT WAR

Redwood Empire combatants fought World War II in a variety of ways. Their stories were often told in letters to family, friends, and loved ones.

ALVIN ZEFF

Zeff was a radioman aboard the cruiser Boise off the Solomon Islands in 1942, when the ship sank 6 Japanese warships in 27 minutes.

"We opened up at spitting range on a new Japanese cruiser. The Boise's first broadside . . . was a straddler—the same thing as being hole high in golf. In 30 seconds, the [cruiser] was down on the bow and in a minute and a half she went under, her screws still turning.

"Next we got three destroyers, one right after another. It took about a minute to sink each one . . . we moved in on a light cruiser, and presto, she broke in half. A big cruiser from the other task force came sneaking in on us. She had our range and was pouring them in. We were taking hits. We went after this big one, which was going parallel to us at a distance equivalent to 14 or 15 city blocks . . . we crippled her so badly that she sank.

"[An ammunition magazine blew up, causing the ship to list badly but] by early morning we were pretty level . . . after emergency patching up, we were able to move again at about 20 knots and we rejoined our ships in battle line."

Dr. Clement Stimson saved the life of a Japanese soldier by amputating his leg while serving with the U.S. Navy off Attu in 1943. The grateful soldier offered to be a servant to the doctor for the rest of his life. (Torliatt Family Collection.)

grabbed my dad around the leg, and shouted 'America.' He said something my dad didn't understand but the translator told him he offered to come to America and be his servant for the rest of his life."

Stimson was the same caring person in his hometown as he was while ministering to the injured and ill of World War II.

GAYLORD HALL

Lt. Gaylord Hall of Santa Rosa was co-pilot of a B-24 on a bombing mission to Germany that had to ditch in the Adriatic Sea between Yugoslavia and Italy.

"When we hit the water with terrific force and went under, I was thrown through the windshield, three of the crew were flung wide, four swam out of waist windows, and two men came up through the emergency engineer's hatch. The nose gunner never came to the top . . . [Settling in rubber rafts with limited rations] the first 12 hours we were all in a state of shock. A few of us had sustained injuries. We began to freeze and shiver, soaked to the skin by icy salt water . . .

"As one day slipped into another, we gradually sank into a state bordering on coma. By turns we rowed and sailed. This was good. It helped to keep circulation alive. Many planes had been seen but our flares failed to attract them.

On the fifth day, with only one flare left, the crew caught the attention of a P-51 rescue plane overhead. "Soon we were aboard [a rescue boat] heading for shore and hospitalization. We were so weak we could hardly stand."

HAROLD MILLER

Santa Rosa pilot Harold Miller was credited with killing German Field Marshal Irwin Rommel, the so-called Desert Fox, in 1944.

"I spotted [a] staff car coming down the road and I made a diving turn. When I got it in my sights . . . I let loose with all my guns. I

Major supermarkets made a major impact after the war, but going into World War II, many Sonoma County residents still relied on neighborhood stores for their shopping needs. One market offered sales on Rinso and Lux soaps as well as Hills Brothers coffee at 30¢ a pound. (Santa Rosa Library.)

was lucky and my first burst scored direct hits . . . the fuel tank exploded and burst into flames.

"[The vehicle] left a trail of burning gasoline for about 200 yards and then swerved into a ditch. Then it bounced into a field and I watched it burn. Then I went back upstairs, joined the other fellows, and went about my business."

On another day, Miller and his plane "Sniffles" were almost shot down.

"I had just blown up two locomotives and damaged three others, when I spotted this airdrome. So I went down with Greenwood,[another pilot], covering my tail. The first [plane] was easy enough. I got it on my first pass, but when I came around again to get the second, a flak tower, so well camouflaged I couldn't see it, opened up on me. Just as my first burst exploded the Jerry (German) plane, a shot of flak caught me in the engine. As I turned into the tower and opened fire, my engine went dead. I thought I 'had it' and expected the flak barn to knock me out of the sky. But not a shot came up. I must have killed the crew. Then I saw that the whole tower was on fire.

(How he got his engine going again) "is still a mystery to me. I just grabbed the engine primer, gave it a few pumps and she caught. I got out of there in a hurry and had to keep priming all the way home. A few times I got ready to bail out but 'Sniffles' kept chugging along so I stuck."

Miller flew more than 70 missions, was credited with destroying 6 enemy aircraft and won the Distinguished Flying Cross and Air Medal.

LURETTA BAPTISTA

WAC Luretta Baptista was stationed in London:

"This is a great life living out of a barracks bag. At a milk bar the other day we stopped to have a glass of English milk. Oh, what I wouldn't give for a glass of Petaluma's ice-cold milk right now. My companion and I went through the main telephone office in London and found it . . . much like ours . . . each morning and afternoon, the operators take time off for tea . . . You know that everything really does stop for tea here. I was amazed and.. .could hardly believe it."

DELBERT TULLY

Delbert Tully, a former tree surgeon, learned to improvise in Anzio, Italy in 1944.

"The [local] farmer's livestock . . . has served us well on occasions. Every once in a while, a chicken gets tangled up in barbed wire (tough break) or a cow steps on a land mine and we have a feast. Even at their toughest, a battlefield steak makes the mouth water . . .

"It's those silly little things like the birds singing, like the Italian woman nursing her baby 200 yards from a Long Tom [gun], like [a] dog herding sheep in no man's land—it's those insignificant little things that remind me of how unnatural this business of war really is and how desperately we've got to fight to get the damned thing over . . . I am in good health and ducking at the right times so far."

LEE TORLIATT ON THE WORLD WAR II HOMEFRONT

"On the morning of December 7, 1941, I was playing in front of my house when my father told me the Japanese had attacked Pearl Harbor. I had no idea where Pearl Harbor was located, but I knew from the tone of my father's voice that something serious had taken place. Air raid drills started later in December, and everyone was required to pull the drapes and wait in the dark until the siren sounded an all-clear. Rumors that Japanese submarines were off the coast increased the paranoia.

"One night, during the blackout, a little baby in Sebastopol [8-miles west of Santa Rosa] got sick and stopped breathing. Two

highway patrol guys volunteered to drive to Sebastopol in the dark, pick up the child, and drive him back to the hospital in Santa Rosa. The cops didn't run into anybody and the little boy was saved.

"As the war fever built up, kids in high school rallied to the cause, taking part in war bond drives to buy jeeps, planes, and equipment for our soldiers. At all the schools, proud students gathered around whatever military item they had sponsored and posed for pictures. Everyone responded to the need to support the boys overseas.

"My two brothers fought in the Pacific; my father became a block warden and had a tin hat to prove it. In all, there were 200 wardens in town. They didn't have much to do.

"When rationing started, everyone lined up in the old all-purpose room at Washington Grammar School to get stamps. Most families got an "A" stamp for their cars, which entitled them to three gallons of gasoline a week. Many food items were in short supply, but my father was on friendly terms with a number of farmers and he bartered with them for extra gas stamps and food coupons. When we took our summer fishing trip to the Klamath River, he always had plenty of gasoline stamps.

Pin-up Betty Grable inspired young women to show off their legs, but the ladies faced a dilemma because of the shortage of nylons during World War II. An innovative group of patriotic women used pens to draw a line down the back of their legs, simulating nylon stocking seams. Gathered in front of Santa Rosa High School were, from left: Peggy King Leiser, June Maher Smith, unknown, Joyce Van Houte, unknown, Bonnie Harbold, unknown, Evelyn Baker Townsend, June Hillard, Billie Newman Keegan, and several more unidentified women. (Santa Rosa Museum.)

THE JAPANESE-AMERICAN
RELOCATION CAMPS

Shortly after the war began, many Japanese from Sonoma County were rounded up and removed to camps where they were held for much of the war, an action that met with almost unanimous public support. Second thoughts came only after the war ended. People wondered whether the creation of these camps was a legitimate defense or an act of racial intolerance.

Historically, like most of California, Sonoma County treated Japanese residents pretty shabbily. Early in the century, many Japanese came to the county as farm workers. Banned by laws barring them from owning property, a few Japanese managed to set themselves up on farms either by claiming to be American-born citizens or by acquiring the land under guardianship.

The presence of the Ku Klux Klan raised fears among Japanese and other minorities in the 1920s. The Klan held its first "outdoor initiation ceremony in Sonoma County" in November 1923, in a field three miles south of Santa Rosa. Ninety men, 4 of them in U.S. Navy uniforms, were inducted into the organization by about 100 robed and hooded Klansmen in a late night ceremony while a fiery cross flamed from a hill across the road. The kneeling candidates were called upon to espouse white supremacy and rigid law enforcement. It was estimated that 500 carloads of people attended the initiation.

When war came, there were 758 Japanese and Japanese-Americans living in Sonoma County, 209 aliens, and 549 citizens, concentrated mostly in Santa Rosa, Sebastopol, and Petaluma.

By early March 1942, it was decided that no Japanese would be allowed to live in coastal areas in Washington, Oregon, California, and some portions of Arizona. All persons of Japanese descent in Sonoma, Marin, and Napa Counties were included in an evacuation order for 5,000 people, raising the total moved to that point to about

75,000. (Eventually, more than 100,000 were taken away.) Families were evacuated to Merced in May and then dispersed to relocation camps.

The Miyanos and Fujitas were two of the Sonoma County families sent to Camp Amache, Colorado.

As a young man, James Miyano was a model citizen. He played halfback on Petaluma's B-class football champions of 1932, and participated in four years of football and track before graduating in 1935. He was a Boy Scout leader, a member of the State Guard, and active in the Japanese-American Citizens League. In spite of his excellent record, Miyano was evacuated with most of his family to Amache.

JIM MIYANO

From the Colorado camp, James wrote home early in 1943. In spite of his confinement, he showed no bitterness:

"We were first evacuated to Merced assembly center [in May 1942]. [We] gathered at Santa Rosa to take the train that took us to Merced . . . where we stayed until August 7. It was sure hot during those summer months. The barracks were 20 feet by 120 feet and 5 families lived in one barracks building. Our family had 5 in a room 20 feet by 24 feet. It was crowded but we made the best of it.

"While in Merced, I got a job as recreation supervisor . . . I was in charge of basketball, football, horseshoe tournaments, and indoor activities. I also carried on the scout movement too for we had a few hundred scouts at the center . . . here in Amache I have 26 scouts . . .

"There were 500 aboard the train which took three days to reach [Amache] and we got off but once to stretch our legs . . . Most of the people were tired and tried to sleep but it was very uncomfortable as there were 44 in my car and we had to sleep 4 in a seat.

"We reached here about 9:30 at night. The first night was terrible as the sand blew sc

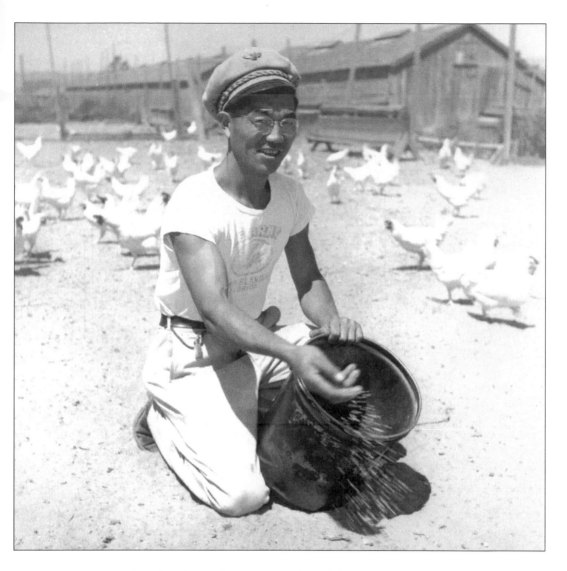

Jim Miyano retained his loyalty to the U.S. even though he was sent to a relocation camp at Camp Amache, Colorado, during World War II. Ironically, Miyano's brother George served in the U.S. Army. (Miyano Family Collection.)

hard you couldn't see. We got in our barracks and made our home for the duration and we have the room fixed much better than Merced.

"The weather here is very peculiar . . . Today it's snowing with a gale blowing too and it's about l0 degrees outside. The rooms of each barracks have a large coal stove and we manage to keep warm. There are about 7,200 persons in this place which looks like a large city. Bad part is that it's sandy and sand gets in everything.

" . . . While I've been here I have been working outside on this project on a farm and we did beet work, working 10–11 hours a day . . . The people here are sure nice to us. There is nothing better than having good American friends, and I'm mighty proud of my friends in Petaluma."

Not all the Miyano family went to Camp

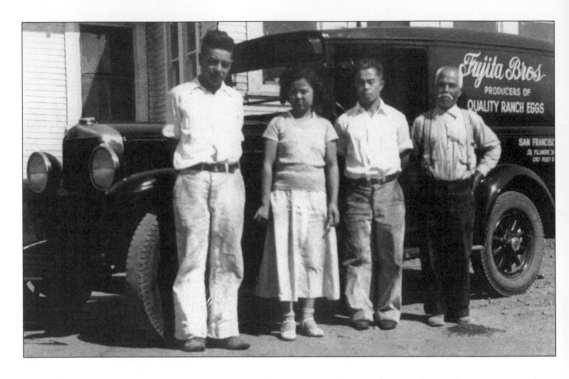

The Fujita family raised eggs before World War II on Ely Road outside Petaluma, using their Graham-Paige truck to make deliveries to their outlet in San Francisco. Tsuneji Fujita (far right) leased and then bought property in the name of his children who were U.S. citizens. They were believed to be the first Japanese to hold land in Sonoma County. With Tsuneji in front of the truck were, from left: Henry Fujita, his sister Grace, and brother George. (Fujita Family Collection.)

Amache. The father, Ishitaro, was detained for a time in New Mexico, while, ironically, James' brother George was serving as a sergeant in the U.S. Army in Boise, Idaho. The only Japanese-American at the post, he worked as a shop foreman in the motor pool, and was treated well by other soldiers.

The Miyanos at Amache originally included mother Tamino, James, brother Sam, and sister Marlene, who had been married less than a year to George Masuda.

SAM MIYANO ON CAMP LIFE

"They must have thought we were very small because the furniture was doll-house size and very uncomfortable. Families were allotted one room, and since there were no separate bedrooms, we had to build partitions from whatever scrap lumber we could find. They gave us cots but we had to scrounge more lumber to make bed frames.

"My mother went to the mess hall and brought back food for the family, and that's what a lot of other families did, too. But when kids got the chance to go to the mess hall on their own, it upset the Japanese elders, because it undermined the sense of family unity.

"There were vegetable gardens in the camp and we even had a chicken ranch run by two Petalumans, Henry and George Shimizu. I did some stoop labor on the beet farm and I worked in the camp post office. I made $12 a month. People at the bottom made $8 a month while doctors and professionals earned $16.

"My sister Marlene and her husband were given permission to go to Reno to pick up two

Pictured here is Ann Sumiko Fujita, wife of Henry, with her son Dennis, who was born at the Amache relocation camp in 1943. (Fujita Family Collection.)

family cars. It was not a pleasant trip when they came back to Amache. They stopped at a hotel in Utah where the vacancy sign was on. They went in and asked the woman at the desk for a room. She turned the sign around to read, 'No Vacancy.' They decided to bundle up and spend the night in the car."

"My mother got quite ill; she had a temperature of 104. We took her to the dispensary but the doctor said he was too busy to see her right away. The doctor said he could see her on his day off, but then she was gone. She was only 50. When we got out of the camp, my father held the urn with her ashes all the way home. He died a year after mom.

"One good thing, we had lots of friends back home. When we had to leave, we rented our ranch to our neighbor, Harold Jensen. He took care of things while we were gone and we got the ranch back when we came home. It wasn't that way everywhere, but we had many good friends."

HENRY FUJITA

Henry Fujita was one of the first Japanese landholders in pre-World War II Sonoma County and a super-salesman of Electrolux vacuum cleaners. Neither fact kept him and his family from going to Camp Amache.

In 1923, Henry's father Tsuneji, an egg rancher on Ely Road northeast of Petaluma, put $5,000 in a trust fund, clearing the way for a law firm to purchase land in the name of his five children, all of whom were minors and

U.S. citizens. It took until 1932 before the Fujitas won the case and became landowners.

Henry Fujita began selling vacuum cleaners in 1936. It was a job he loved and he stayed at it for 44 years. Relocated in 1942, five Fujitas stopped at Merced where Henry said:

"The buildings we live in are just like chicken houses. The entire camp was put up in a great hurry and the contractors apparently employed any one who could use a hammer and saw . . . in many rooms, morning glory and other hardy weeds have grown up between the cracks in the floor . . . We are also bothered with crickets, grasshoppers, and many other varieties of bugs, insects and mice and rats. Fortunately we have a concrete floor and though it is hard on the floor brush we find it easy to clean with our Electrolux . . .

" . . . We have a barbed wire fence around the entire camp with high guard towers, manned by armed soldiers . . . In the middle of the [first] night [at Merced] the sky opened up . . . and though the buildings were new, they leaked like sieves around the doors, windows and . . . the roof. In our little room we had about seven roof leaks. Nearly all of us caught colds. On July 13, I went over the head of the camp doctor . . . and reminded the camp manager that there might be more unnecessary deaths in camp if conditions were not improved. The camp manager made immediate arrangements to have our children examined at the Merced County Hospital. [Son] Gary was able to come home the same day with new medicines, but [daughter] Nancy was cared for in the County Hospital for six days.

"[In September, on the train to Camp Amache] three of us occupied two seats facing cushions like a mattress and two fellows slept in one direction and I slept between them in the other direction. We slept in our clothes and as it was warm and with a crowded car and with the close proximity of three bodies on two seats we slept in our shirt sleeves and perspired . . . so ended the first day . . . [On the second night] we called it a day and turned in the same as the first night. We all put on new socks so we wouldn't offend each other too much.

"We were fortunate to be located [at Amache] . . . where a lot of lumber was piled. As at Merced, we all helped ourselves to the lumber. I made [wife] Ann a six-drawer dressing table, for Gary a bed with two huge drawers under it, two night stands . . . and shelves and I'm still making other things."

Miyano went back to Camp Amache in the mid-1980s but "I couldn't find the place . . . one man told me to take a road and that led me to the camp. When I arrived, I found there was not much left . . . there was a monument to 11 or 12 Japanese from the camp who had been killed in the war."

The U.S. government eventually agreed to pay damages to many survivors who lost time, money, and dignity in World War II relocation camps.

LOUIS FOPPIANO ON THE GERMAN POW CAMP

Sonoma County did have one camp. At Windsor, between Santa Rosa and Healdsburg, a prison camp was set up for German prisoners of war.

"During the [second World War], we first had German prisoners. I used to get 20 or 25 to do our pruning and our picking. I was on the board for getting the help, because we had no help; all the boys were in the army, and then everyone went to defense—Mare Island and Kaiser [shipyards]. The first help we got was German prisoners, and we had them right down here at Windsor. They came off the submarines, and boy, were they ornery! They were a tough bunch of boys . . .

"They sent a soldier with a rifle, and he watched them. He watched them pretty close. We had a prison camp 4 miles down the road here. They were young boys, 18 or 20 . . .

"When our country went to Africa . . . we captured . . . Rommel's group. They were a different class, and we had them for a year or so. Then the war was over, and they took the Germans away."

CHAPTER 9

Demon Rum

In spite of strong efforts by the Women's Christian Temperance Union to stamp out "Red Eye and Tangle Leg," alcoholic beverages were readily available in Sonoma County. John Jarr, who migrated from Germany in the 1880s, became a retail beer dealer and made regular deliveries in his Wieland Brewery wagon. (Torliatt Family Collection.)

The Women's Christian Temperance Union has had a long and distinguished history fighting the evils of demon rum. It has not always been a winning battle. In San Francisco and points north, many people were lured to taverns to quench their thirst. While the WCTU denounced alcohol abuse in Sonoma County, at least one newspaper came to the defense of the hometown barkeeps.

In 1885, it was noted that there were 3,100 saloons or places where liquor was sold in San Francisco while southern Sonoma County had less than half a hundred taverns where liquids such as "red-eye" or "tangle-leg" could be found. There was little chance that a resolute drinker would succumb to thirst, however, given the fact that there was one bar for every 15 voters.

WILLIAM BORBA ON P. JACKSON McQUADE

"As most towns did, Sebastopol had its share of characters. There was P. Jackson McQuade, a Latin scholar who fell prey to alcohol, and when well engaged in this pastime, would endeavor to hold conversations in Latin with the nearest doctor, druggist, or priest who had knowledge of that tongue. His epitaph read:

'HERE LIES BURIED P. JACKSON McQUADE,
THE D_____ST RASCAL EVER MADE
SPIT ON MY GRAVE AS YOU PASS BY
FOR WHEN ALIVE I WAS VERY DRY.'"

"Then there was Bill Garrison, horse trader from Guerneville, who had a glass eye, and when indulging his penchant for drink,

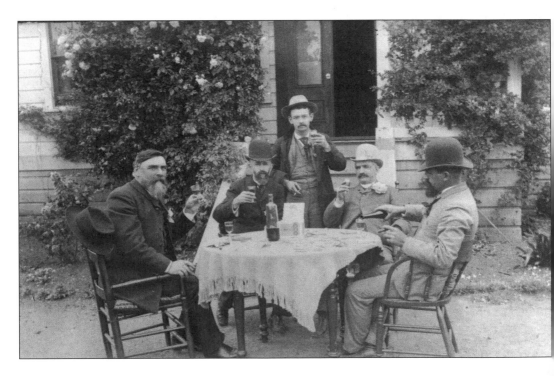

Businessmen settled down for a friendly wine tasting early in the century in Santa Rosa. The group, from left: J. Shaw, Buckland, J. Piggott, G. Eliason, and F. Kerraduel. (Sonoma County Museum.)

would exclaim, 'Oh, lord of love, look down from above, and pity my condition; send me down two d___ good hounds and plenty of ammunition.'

"There were 14 saloons, and the stores stayed open until 10 p.m. and on Sundays. Around 1882, local residents gathered to peer at the arrival of women of the town [from the First Street section of Santa Rosa] who came by surrey to make merry at Pat's Saloon [using the family entrance]. Word would spread rapidly that they were approaching, and the citizenry gazed, horrified, at the visitors with their high-heeled shoes, dresses clear up to the ankle, painted faces, and *smoking*."

After World War I, the U.S. government declared war on Demon Rum. In 1919, the 18th Amendment was passed, curbing legal manufacture and sale of liquor. Critics complained the amendment turned ordinary citizens into lawbreakers. Many immigrants from southern Europe saw alcoholic beverages as part of their daily life. What kind of joke was this, they asked, that the government would keep them from having a glass of wine with their dinners?

The situation was complicated by the fact that Sonoma County produced large quantities of both wine grapes and hops. Production and use of alcohol was a part of daily life.

LOUIS FOPPIANO

"The American people weren't drinking much. It was the Italians and other immigrants who came over from Europe that bought the wine . . . "

ED FRATINI

"There were many speakeasies [*sic*], they were all over town . . . I recall the Riverside . . . it was a saloon, with the usual water trough in front, and boarding house for some of the workmen who worked on the stone rock quarries . . . south of town. The Riverside was eventually replaced in the 1940s by a popular restaurant and bar called The Colony. You could have a drink at the Willow Brook Saloon [north of town] go along about a mile and stop at the Rainesville Saloon [Little Pete's] and about another mile and a half be at the Washoe House. One good thing: those horses knew the way home and delivered the owner without incident."

GUIDO BOCCALEONI

Old-time accordionist Guido Boccaleoni did part-time work in his youth delivering illegal whiskey to speakeasies in a Model-T truck. The "speaks" were usually located in a small room in the back of a grocery store. Boccaleoni said there was little fear of arrest.

"Everybody got paid off. Money does strange things to people, if the stack is high enough," he said.

After making his deliveries, Boccaleoni brought out his accordion to serenade bootleg bartenders and their customers.

MARSHAL W.J. ORR

While there were sporadic arrests on land and at sea, many people took advantage of loopholes in the Prohibition laws. Family wine-making was allowed up to 200 gallons per person and wineries could make sacramental wine for religious purposes. The ethical agonies of Prohibition became obvious when the W.J. Orr, the City Marshal of Cloverdale, arrested his son William for violations of the Prohibition laws.

"Young Orr . . . was sentenced to pay a fine of $150, which he did. [The senior] Orr said . . . that it was rumored that the wet interests are circulating a petition calling for [my] recall . . . " It was not clear whether young Orr ever signed the petition.

Liquor moved north into Sonoma County

via the Petaluma river, and went south to San Francisco via trucks that motored almost nightly down the 101 Highway. Some of the liquid came from Canada, some from wineries in Sonoma and counties to the north, and more from illegal stills hidden in remote sites along the North Coast. Stories are told of burying the illegal hooch in readily-available cow manure to hurry the aging process.

A Stream of Red

A large amount of illegal liquor was confiscated en route to San Francisco. In Petaluma, "Officer O. Rudolph arrested a drunk and as the night was cold, placed him in one of the cells adjacent to the office of Police Chief Mike Flohr, instead of the main prison, which is very cold. The officer did not know that the cell contained a 50-gallon keg of wine which had been retained from the wreck of [a] bootlegger's truck . . . When a tiny stream of red trickled through the cell door . . . the officers present were quick to [put] the drunk in another cell and the bung back in the wine cask, which he had broached . . . Little wine was lost, except what the prisoner added to his load."

Confiscation of wine and trucks almost turned Petaluma into a fermented lake.

"There is a sour smell about the city hall, police station, the corridors, the yard, and the corporation sheds . . . this morning, without previous announcement, over 2,000 gallons of seized wine . . . were quietly rolled into the office of Police Chief Flohr . . . where it was all without ceremony dumped into the sewer . . .

"And while the wine was being dumped, it overflowed from a sewer vent and overflowed into the city hall yard and corridors and the sour wine smelled to the heavens . . . hundreds of gallons of perfectly good vinegar and lots of fairly good red wine went to debauch the fishes . . .

"The barrels were saved and will be sold by the city . . . shortly the city will inaugurate a clearance . . . sale of barrels and casks of all sizes, shapes, and degrees of usefulness."

Some aspects of Prohibition tended to be comical, but there was a deadly serious side, often involving rum runners, hijackers, and federal agents. It was high drama when the various forces met on the Pacific Ocean at Point Reyes in 1924.

Drinking from the bottle became a common practice during Prohibition. (Healdsburg Museum.)

The Gun Battles

"Four-hundred cases of Scotch whisky, three high-priced automobiles, one 3-ton motor truck, four prisoners, and two small boats were captured by three Prohibition officers . . . in a sheltered inlet . . .

after a series of gun battles in which the government agents ran the gauntlet of a midnight ambuscade of 'high jackers,' a skirmish attack of outposts in scout cars and . . . a pitched battle on the beach."

A couple of years later, "Rum runners and Prohibition agents, with machine guns on the one side and automatic pistols on the other, fought it out on the beach near Bodega Bay . . . The smugglers, under cover of machine gun fire, retreated . . . safely to sea, apparently escaping unhurt in the rain of bullets from the pistols . . . of agents W.H. Paget, Geo. Hard, and Carl Ahlin . . . Hard and Paget both had narrow escapes from death . . . Three shots passed through the crown of Hard's hat and one cut through Paget's sleeve at the shoulder just as he raised his arm to fire."

DRINKING UP THE EVIDENCE

The great gun battles between the Feds and their adversaries sometimes led to peculiar hangovers.

"Sunken treasure in the form of smuggled liquor thrown overboard last week by the crew of a rum running launch . . . halted the fishing industry at Tomales Bay for several days and for a time created a scene rivaled only by the legends of Captain Kidd.

"Discovery of the wealth beneath the sea was made . . . when a party of fishermen, members of the Tomales fishing fleet, hooked a case of pre-Volstead Scotch while trolling the bay. The catch was hauled ashore by the fishermen, who at once returned to the spot and landed another case. The word soon spread . . . and the rum hunt was on . . . the enthused fleet dragged 40 cases of the contraband rum from the bottom of the bay . . . those who were lucky enough to rescue a case attempted to destroy the evidence at once, with the result, as one of the boys put it, 'it was a large night.'"

LIQUID FIRE EXTINGUISHER

On one occasion, the illegal booze was turned into a fire-fighting tool.

"Fine old wines were used to fight flames as fire . . . destroyed the home, winery, and tankhouse on the ranch of John Alten of Fulton . . . the blaze caused the destruction of 11,600 gallons of wine . . . When the seams of a huge tank of wine began to spread, releasing a flood of the liquid onto the ground and into the ditches nearby, the neighbors and others who had volunteered their services as fire-fighters, began dipping sacks in the fluid or filling buckets . . . the unique fire extinguisher material proved of service in checking the spreading flames."

VOLPI'S RESTAURANT

"During the years of Prohibition, this was one of the few places in Petaluma where one could get a drink. Local ranchers would bring their milk and eggs to town and have a drink in the back room while their grocery list was being filled. Alcohol was never produced on the premises, but was supplied by stills located one mile out of town."

FRED BARNES

Fred Barnes came from pioneer stock. His father, William Perry Barnes, arrived in Santa Rosa in 1846–47, and farmed on Barnes Road off Fulton Road on the west side of town. Fred, born in 1903, was a young man when Prohibition came to Sonoma County.

"They used to bring the booze in at Salt Point [in northern Sonoma County] from Canada—White Horse . . . I was goin' abalone huntin' at Salt Point and I couldn't get anybody to go with me so I went alone. I had a '26 Hudson . . . I went up there and I parked. I knew they were bringin' booze in

there 'cause they had the line out from the bank. Anchored out there—pulled the launch in under it with the booze on it—hooked it onto the line and pulled it in . . . I got just down to where I could see the ocean an' I turned around a turn an' a guy stuck a gun in my face and said, 'Where're *you* goin'?' I says, 'I was goin' abaloning.' He says, 'Are you alone?' So I stayed there and talked to the guy for a while. He says, 'Just stay here a few minutes. Go on about your business.' They was bringin' the booze in an' stackin' it up down there. When they got it all in, the launch left. Then the guy says, 'Come on now, we'll go down and meet the boss.' So I went down there and this guy was there an' we got to talkin' an' the first thing he asked me was what kinda car I had. So I told him. And he said, 'You wanna make a run up to Williams for me with a load of booze?' Hell! A dollar them days was a dollar, boy! I think he said, 'When you get there, there'll be $100 waitin' for you.'

"He told me to go to an old garage [in Williams] and get out of the car. When I got back, the car was empty. And the money was laying on the seat. How many bottles did they get in the car? Oh Christ I don't know. The whole back end was full! I didn't count it. They loaded it and unloaded it an' I never touched it. Anyhow, I loaded three or four loads for that guy. About every eight or ten days he'd call me up to tell me when to come. I was making $400 a month and not doin' nothing! I never had time for abaloning anymore.

"Every once in awhile the bottles come in gunny sacks, 12 bottles to a sack. Every once in awhile, when they were bringin' 'em in, the sack would rip and the bottles would fall in the ocean. So after they got through hauling it in there; after the feds got on it, you'd go there abalonein' and the first thing ya know yu'd pick up a bottle of Scotch where it'd been washed in.

"They had a big still out here where the Guerneville Road crosses the lagoon . . . Used to be a big dairy on the hill . . . 'Stead of running a dairy, he just had the cows there

for a bluff. Wasn't milking 'em. The big barn was a whole big still. I don't know who was running it, but . . . it was the Illingsworth ranch. I used to hunt ducks there. Anyhow, he was making it and puttin' this raw alc in brand new 5-gallon cans and stackin' it in the barn away from the still. So the feds come in on him. So he runs out of the place an' went down an' got in the boat and crossed the lagoon. Well [the feds] didn't get him. But they had the still and five or six hundred cans of raw alc stacked up there. So who do the feds get? They had to get a guy to watch the place til the next day when they could haul it off. So they got Tom Brady. And Tom Brady was a cousin of Rosco Johnson's wife. An' I was working for Rosco [as a mechanic]. When Tom got out there, the first thing he did was pick the phone up and call Rosco Johnson. The first thing he says is, 'Get the back seats out of a couple a cars and get out here!' So out come the seats and out there we went. We loaded the back of those two cars of all we could get in it of 5-gallon cans of pure raw alcohol! We hid it under Rosco's house on Mendocino Avenue [about where Eggen & Lance Mortuary is now]. We went and got some oil of Juniper and distilled water and started making gin. We had enough 'Jack' there for two years! All you wanted!

"Right on the corner of Main and Second Streets there used to be the Burbank Hotel . . . upstairs in that hotel was a guy run a bootlegging joint for years. Every deputy sheriff, sheriff, every lawyer and judge when the court session was off in the evenings, you'd see 'em all walk down Main Street and turn the corner onto Second and go upstairs for their drinks 'fore they went home. He sure never got bothered."

GUERNEVILLE OLDTIMERS

"The Feds came to blow [a] still up [near Guerneville] on a Saturday. The man who had the explosives in town was Charlie Bean, a Seventh Day Adventist. Saturday was

his Sabbath and when he was asked to accommodate them, his answer was no. After they showed him their badges, he still said no. The Feds said, 'We'll put you in jail.' And Charlie said, 'O.K. But I won't sell the dynamite or blow up the still.' The Feds asked, 'Where's the key to the powder magazine?' Charlie answered, 'Home in my pants pocket.' To which the Feds got the key, got the dynamite, and blew up the still."

LOUIS FOPPIANO

Louis Foppiano, from one of Sonoma County's major wine-producing families, has many memories of drinking habits before and during Prohibition.

"We sold the wine in 50-gallon barrels. In those days, you never bottled. I don't know if even Italian Swiss Colony bottled. They'd put a spigot in the 50-gallon barrel and put them into stores. You'd come in with a gallon and fill it up, go home and drink it . . . we never thought of bottling.

"We planted Alicante when Prohibition came in, because that was the grape that the New York people wanted to buy . . . It wasn't good wine, but they drank it and sold it . . . It was lucrative when Prohibition first started, but after four or five years, the price of grapes went down . . . [during Prohibition] I know what was going on. There were stills around here, and they made alcohol just about anyplace in these hills . . . they'd sell it to speakeasies in the city. They'd put a little oak or caramel in it and sell it to people. It might kill them, when you see what it was made of."

In 1926, because the Foppianos had 100,000 gallons of the 1919 vintage turning to vinegar, they opened the valves and dumped the liquid in a ditch along Old Redwood Highway. It turned into a giant street party.

"Everybody in town came over and picked up the wine—in 5-gallon buckets, jugs, quarts, tin cans, anything they could pick up . . . some of them were drinking wine right out of the hose."

MILT BRANDT

Because of Prohibition, "business was in shambles" at Brandt Bros. brewery. Although they still owned rural property, the family moved to town in 1932, when times were bad. However, there was a sudden change of fortune.

" . . . Dad came in around supper time with a big smile on his face . . . he reached for his wallet and produced a $500 bill. Mom just about passed out and . . . [my sister] Dorothy and I didn't know what it was, since we hadn't seen anything larger than a 20, and very few of them. Dad said this was off-season rent for the dehydrator [at the ranch] . . . we were sworn to secrecy not to discuss any of this with our friends.

" . . . the $500 bill was rent on the dehydrator building all right, but none of the renters happened to be interested in the prune business. Their interests laid in bootlegging . . . 180- proof alcohol. What to do with the waste it produced in the distillation was the big question. The dehydrator was located adjacent to the river and the rising water during winter rains was natural to dispose of the waste, along with odors it produced when 'cooked off.' A pipeline was conveniently installed to the river and that took care of that.

"[Later] Dad raced in . . . saying [the Feds] had knocked over [Botch] Foppiano's still which was located on the school site of where now stands Rio Lindo Academy. Mom, Dorothy and I wanted to see the results of an operating still that had been raided. We all climbed in the Model-T sedan and took off up Bailhache Avenue. Before we even arrived at the site you could smell the results of the raid. The Feds really did a number on this location.

"I've often wondered what our family would be like if Carrie Nation hadn't gotten the idea that all alcohol was evil and decided to correct the problem . . . Dad never lost his touch making home brew, and always attracted many old friends who hadn't forgotten his expertise."

Dumping of old wine turned into a party along Old Redwood Highway as revelers gathered near Foppiano Winery in 1926. A federal agent (standing) looked on as celebrants ignored him, either swigging on a bottle or sleeping it off. (Healdsburg Museum.)

John Volpi worked behind the bar at his deli and saloon in downtown Petaluma, doing a thriving business, it is rumored, even during Prohibition. Volpi was also one of the accomplished accordion players of the time. (Volpi Family Photo.)

John Foppiano, pictured here in his vineyards in 1994, grew up during the Prohibition years and went on to build his winery into a formidable force in Sonoma County. During Prohibition, he said there were numerous stills in the hills around Healdsburg, producing wine that was shipped to the speakeasies in San Francisco. (George Hower Photo.)

CHAPTER 10

Sports

Competitors in the marathons of 1927 and 1928 ran to the Ferry Building in San Francisco and stopped until all the other runners arrived to take the ferry to Marin County. In Santa Rosa, the arched Santa Rosa/Redwood Empire sign greeted the runners as they ran north on Highway 101. Photo was taken looking south from Fifth and Mendocino Avenue. (Sonoma County Library.)

Distance runners striding along the streets and trails of Sonoma County has become a common sight. The more hardy souls test their mettle in grueling marathons of 26 miles, 385 yards. Such efforts seem like child's play compared to the great Indian Marathons of l927 and l928. While many of the fun-seekers of the '20s exercised themselves by doing the Charleston and becoming marathon dancers, a group of Native-Americans, young and old, ran themselves ragged in a marathon race to end all marathon races. The trail took them from San Francisco up Highway 101 through the

Native-American runners, armed with ragged running shoes and strong hearts, competed in the grueling 480-mile marathon from San Francisco up the Redwood Highway to Grants Pass, Oregon in 1927 and 1928. Manuel Cordova of Healdsburg, using the nickname Humming Bird, ran in the second race. A doctor ordered him out of the race after 40 miles. (Healdsburg Museum.)

Redwood Country to the finish line at Grants Pass, Oregon.

The distance—480 miles.

The 1920s races were the brainchild of the Redwood Empire Association, which wanted a promotional gimmick to induce tourists to travel on the three-year-old Redwood Highway. In addition, there was a cultural message. The event was designed to "prove to the paleface world that he [the Indian] is not a dying race, but a strong and virile one."

To handle the promotional task, the REA hired Charlie "Cash and Carry" Pyle of Santa Rosa, who had made a name for himself as one of the first-ever football agents, getting a good deal with the Chicago Bears for famed running back Red Grange.

Runners in the 1927 race were offered rewards of up to $100 for being the first to reach a particular city, and the overall winner got $1,000. The event caused a major stir in communities along the way where people lined the streets to cheer the men on. Shrill sirens were used to alert residents that the runners were approaching.

The first run came on the heels of the historic flight of Charles Lindbergh across the Atlantic in the *Spirit of St. Louis* in May 1927. The race was scheduled to begin June 14 in San Francisco and end "nobody knows when in Grants Pass."

Eleven Indian braves gathered in San Francisco, including three Zunis from a reservation near Gallup, New Mexico, who would carry the colors of Marin and Humboldt counties and the city of Willits. It was reported that the three competitors took their first rides on a train to get to the starting site. The group included Melika, over 45; Chochee, "a few years younger;" and Jamon, age 32. Melika aged rapidly. By the end of the 1927 race he was listed in his 50s, and in 1928 at over 60.

Eight runners were Karook Indians from Happy Camp on the middle stretch of the Klamath River on the Oregon-California border. Years later, Mad Bull, whose real name was John Southard, told how he and his fellow Karooks got into the race. Bull, 23,

like many of his running mates, had never traveled farther than the nearby town of Happy Camp in the Klamath Mountains.

C.H. Boorse, owner of the Happy Camp General Store, talked four young men into entering the marathon under his sponsorship. They were the Southard brothers—John, Gorham, and Marion—and a man named Henry Thomas. The store owner gave John the name Mad Bull. Marion became Fighting Stag, Gorham was Rushing Water, and Henry ran as Flying Cloud. Mad Bull's nickname was in contrast to the man himself: a mild, smiling, methodical person. Merchant Boorse, who hoped to put Happy Camp on the map and perhaps make a few dollars betting on the town's runners, put his entrants on a special regimen, Mad Bull recalled at age 80.

MAD BULL

"I can't understand how Boorse came up with those names [Mad Bull, etc.] He was an odd man.

"Every morning he would wake us up at five o'clock and make us run down and jump into [freezing] Indian Creek. I could hardly stand it."

To build stamina, the merchant had them run 30 miles daily up the Klamath to another village called Hamburg, and 30 miles back to Happy Camp. Boorse followed in a car, yelling advice.

While the Karooks trained heavily on rugged Klamath trails for two months, the Zunis of New Mexico ran long distances on a continuing basis as part of their traditional tribal activities. They were known to log 60 to 80 miles a day in tribal athletic events.

THE FIRST MARATHON

When he got to San Francisco, Mad Bull complained, "I got a crick in my neck looking up at the high buildings . . . I was right out of the mountains."

"[At Civic Center] It was cold and foggy, like San Francisco is most of the time. People were cheering us. Crowds lined Market Street. They had stopped the street cars just for us."

On race day, Mayor James Rolph of San Francisco and Al Jennings of Eureka manned the starting line in San Francisco's Civic Center. Jennings, an ex-Oklahoma badman, started the race with an old Colt .45. At the line, runners were reminded that they must "finish in 15 days, don't accept lifts, and don't get off the Redwood Highway." An entourage of assistants followed each runner, and there were five inspectors.

The runners, dressed in white shorts, hit Market Street at full speed as crowds cheered and street cars stopped to give them a clear path. The runner who reached the Ferry Building first gained nothing but bragging rights. Since the Golden Gate Bridge did not exist, he had to wait for the others to arrive so they could all board the ferry to Sausalito in Marin County. Once across the bay, the runners began to string out through the Marin countryside.

Race officials and police did their best to keep cars from following too closely and gagging the runners on their exhaust fumes. Each runner was accompanied by a back-up team traveling in a car that carried food, drink, extra socks and shoes, and a cot, in case a runner could not make it to a town with a hotel.

Jamon, the youngest Zuni runner, led the run to San Rafael and won the first $100 prize. But there was a catch: to get the money, he had to finish the race. Jamon set a strong pace, covering 14 miles in an hour and 19 minutes, but there were still well over 450 miles to go. Bothered by blisters, he dropped out north of Santa Rosa.

North of San Rafael, Flying Cloud took control of the race. He led the field up the main street of Petaluma, trailing behind traffic officer Ernie Roberts, who made sure the road was clear. Local folks had little to cheer about: their representative, Petaluma Hawk, who was really G. Rockey of Willits, was never

among the leaders. Still, Petaluma provided a traditional welcome. When the Zunis and their trainer came into view, they were presented with World's Egg Baskets by high school girls Pauline Boysen, Jean Sweeney, Helen Kenneally, and Dot Beiddleman.

CHARLES TORLIATT JR.

"The whole town turned out to watch the runners . . . They headed up the main drag . . . the crowds kept cheering as the runners went by. One of the runners waved at me and I waved back. He looked like he was still pretty strong. I was just a little kid but I knew something pretty unusual was going on."

Although he was behind all the first day, when evening came, Mad Bull picked up speed and passed Flying Cloud, who was sleeping in a motel in Santa Rosa. The two men didn't much like each other and the marathon intensified the rivalry.

MAD BULL ON THE MOVE

"'Cloud' picked up the $100 bonus posted in Santa Rosa for the first runner to hit the town. But I kept right on running. I stopped . . . every four hours to change into fresh socks and dry running shoes. I wore boxer's shoes with double soles.

"Boorse gave me a big glass of orange juice with two raw eggs in it. It kept up my strength and didn't overload me. I drank water from the springs along the road. There were good springs everywhere . . . I never ran uphill . . . it kills you off. I walked uphill and ran downhill.

"I got the $100 bonus in Garberville. Somebody rushed out from the curb, and shoved an envelope into my hand. I looked inside and saw three $10 bills. That was nice.

"My brother Gorham got ill and dropped out of the race . . . I kept going. I was in good shape. The doctor said I had a bigger,

stronger heart than most people. It pumped all the blood I needed to keep running 6 miles an hour, hour after hour. At times I felt like I couldn't run another hundred yards. But I'd keep going until I got my second wind. If you stop, you never get it.

"[At the end] I could have run another 5 or 6 miles, maybe. Maybe not."

ELLEN HALL

"[In Healdsburg] on graduation night from high school we were allowed to stay up through the night because there was a special event happening. There was an Indian marathon. Indians were running from San Francisco all the way to Oregon."

With runners dropping out, the eight men still in the race rolled through Hopland early June 16. Mad Bull was 2-miles ahead. The two remaining Zuni displayed a "peculiar sliding step," which, it was decided, was either an exotic tactic or a sign of fatigue. Blisters, heat, and hills took their toll, and runners stopped for treatment. They were hauled by car into the nearest town and then driven back to the place where they had been picked up to continue the race.

By June 17, Mad Bull led by an estimated 24 miles, and Flying Cloud was second. Melika, the grand old man, received a hero's welcome when he came into Willits, the town that adopted him for the run. The fire department and local band marched out to welcome him. He responded with a tribal dance to implore the gods for success. He muttered incantations, and chewed and spat berries. He also threw powder in the air to encourage the gods to throw dust in the eyes of other runners so he could catch them.

Sam Brown, manager of the Pacific Telephone and Telegraph District office in Petaluma, and his wife were on vacation when they met runners near Eureka in Humboldt County. Brown chatted with the various runners, then stopped in Garberville to phone the latest news back home.

A Little Boy Named Garth Sanders

"Eureka had about 15,000 residents and at least a third of them lined Broadway and Second Street to watch Mad Bull run. A bucktoothed kid of nine years stood on the curb . . . and watched the sagging leader of the great marathon jog past. That kid was me. I was disappointed: the grownups had made such a big thing about the Indian angle that I'd expected Mad Bull to be in feathers and buckskins. Mad Bull made it to the Vance Hotel . . . where he stopped for another hot soak before going to bed. He made another $100 by being the first into Eureka."

From Crescent City, Mad Bull "kept going as fast as I could." It was nearly midnight when he reached the outskirts of Grants Pass where a crowd of 4,000 awaited him. With one last burst, he broke the ribbon with his chest. Miss Redwood Empire, also known as Little Fawn, gave him a kiss before he slipped away to a hotel for a hot soak and sleep. The next morning, to please local residents and movie cameras, he reenacted his trip to the finish line.

Mad Bull finished the run in 7 days, 12 hours and 34 minutes. He averaged 60 miles a day and had run the equivalent of 18 conventional 26-mile marathons. Flying Cloud was 10-miles back in second place. Melika, the only Zuni still in the race, was in third place. They won $500 and $300 respectively.

As soon as he could get away from the award ceremonies, Mad Bull left to buy a "brilliantly-painted" sedan. Cost: $1,000. He ordered the name "Mad Bull" painted on its sides in gilt lettering.

The Aftermath

"[After the race when Mad Bull and other Native-Americans appeared on stage in rural movie houses] we pretended we were Indians camping out. We acted like fools. I had a big, old feather headdress. I made $50 one night."

The 1928 Marathon

A second marathon was run in June 1928 and prize money swelled to $10,000, with $5,000 for the winner. This time, six Zunis, billed as "bronze sons of the Arizona sands," registered. They ranged from Melika, now 62 years of age, to a youngster named Sheeka, age 23. All were under 5-feet, 6-inches tall and in good physical condition. Petaluma sponsored Gary Boeke, a Pomo who borrowed the name of Petaluma Hawk. Chief Geyser represented Geyserville, and the Zuni Chochee, who had run in 1927, came back as Santa Rosa's man. Chief Humming Bird ran for Healdsburg.

James McNeill (Great White Deer)

"Let's look at what motivated the running of the race in the first place . . . the Redwood Highway [from San Francisco to Grants Pass, Oregon], was completed . . . in the early 1920s . . . the California land sharks . . . gobbled up all the desirable land along the Eel River, the Russian River and all the other nice places. Large hotels and auto camps . . . sprang up along the flats by the rivers. The Douglas Memorial Bridge at Klamath was completed . . . [but] the tourists didn't come.

"The idea [for a marathon] caught on right away. [The Redwood Empire Association] set aside $100,000 to finance the race, $10,000 to be the prizes and $90,000 for incidentals.

"Mr. Boorse asked me if I would like to try the race . . . I went from 236 pounds to 218 . . . they had set up camp at Cotati . . . and when we arrived I went into training. I weighed 198 pounds which was still overweight but I could carry that.

"Each inspector saw to it that we traveled alone at night . . . they were afraid our manager or trainer would masquerade for us and let us ride in the car . . . [When the race started] I was the third man to reach the Ferry Building [in San Francisco] and that was the nearest to the lead I ever was.

"[In Marin County] . . . two of the boys

took off running up the grade: Rushing Water from Happy Camp and one of the Zuni boys by the name of Amon [Jamon]. They ran just like they were out for a 100-yard dash and when they got into San Rafael, Amon collapsed into the movie camera. Rushing Water passed out in Petaluma and was out of the race there and Amon gave it up just past Santa Rosa. The rest of us just jogged along.

"I overtook Flying Cloud [who] . . . was sitting down on the running board of a car changing his socks . . . he looked just like a human dynamo. I didn't see him again until Grants Pass and neither did anyone else because he took the lead that night [and won the race].

"I made it to Eureka . . . and by that time I had worn out the soles of two pairs of shoes. When I got to the Smith River [north of Crescent City], one of the Warner Brothers came along with [movie star] Myrna Loy. I . . . was sweaty and dusty and dirty. [Warner] wanted a picture of me with Myrna so we sat on one of those stone walls that go up the Smith River Canyon."

A surprise participant was a Caucasian runner dubbed "Paleface Yellowred," an unnamed amateur athlete, who ran to defend "white pride." He was never a factor in the race.

The 29 starters in 1928 included Mad Bull and Flying Cloud. Once again, Jamon led the way to San Rafael, but Flying Cloud took the lead near Novato. Mad Bull, bothered by sore legs, fell well back into the pack.

North of Eureka, Flying Cloud was forced to slow down because of bleeding from the mouth and nose, but he gave up little ground. After 7 days, Flying Cloud finished 17-miles ahead of the field. The aging Melika was a distant second. Melika said he would use his $2,500 second-place money "first [to] buy an automobile . . . and [then] a flock of sheep to keep me when I get old."

The stock market crash in 1929 and the ensuing Depression put the squeeze on tourism and the Redwood Empire Association treasure chest, dashing thoughts of continuing the marathon.

THE UMPIRE SMACKER

Softball was a popular form of entertainment in the early-20th century in small-town America. Fans came out in large numbers to watch family or friends in action. Peter Torliatt Jr., who played in the 1920s and '30s, had his moment of fame in 1933, a season in which he was declared the Babe Ruth of Petaluma softball. Playing second base for the Young Men's Institute, he led the league in hitting with an average of .647 and smacked 4 home runs.

"[Torliatt] is the monarch of all he surveys in the way of apple knockers."

Torliatt's greatest year was almost his last. He barely escaped with his life when his on-field antics came close to disaster.

PETER TORLIATT JR.

"Late in the season, they arranged for an all-star game for a guy who had been hurt earlier in the season. I felt pretty good when they picked me to be manager of one of the teams. A lot of people showed up, and we gave them a few laughs. The pitcher substituted a ripe cantaloupe for the ball, and the batter from the other team took a big swing and smacked it to pieces. That always got a good laugh from the crowd.

"I was told to give the umpire a hard time, and I did, right from the start. We played four or five innings, and it was my turn to bat. They told me to keep picking on [Joe] Avila [who was the umpire]. I took a paper bat up to the plate and when the time came I hit him over the head with it. The bat bent in two but I quickly snapped it back so it looked like a real bat. I didn't realize until much later that that could have been the end of me."

A newspaper account said, "Torliatt came to the plate swinging the bat viciously . . . [the umpire] called some sour ones . . . [The batter clouted] 'the Weasel' [which was nickname for the umpire] over the head with a crack that could be heard in Cotati [8-miles away]."

Torliatt continued, "Joe did a perfect swoon. Right on cue, stretcher bearers came in, scooped him up, and packed him away. The only problem was, nobody knew it was a joke except my teammates. Some guy from the other team yelled he wanted to wrap a bat around my neck. My teammates circled around me, but things got pretty ugly. The people in the stands thought it was the real thing, and started yelling at me and jumping on the screen [between the stands and the playing field]. Fortunately, the screen went all the way to the roof."

Before further damage could be done, Avila "came dashing back in fine shape . . . garbed in a Chinaman's suit, pigtail and all."

When the YMI met the Eagles in a playoff for the league championship, the newspaper announced that one team would be led by "Home Run Pete, the Umpire Smacker."

THE GREAT RIVALRIES

In modern America, teenage sports traditions have often built around crosstown rivalries. In earlier times, when there was only one high school per community, the hated "Big Game" enemy usually resided in a nearby town. Until the 1950s, the Redwood Empire's biggest natural rivalry pitted Santa Rosa against Petaluma, communities separated by 16 miles of two-lane road.

Tension between the two cities went back to the Civil War when Santa Rosa gave its sympathy to the South while Petalumans rallied to the Northern cause. Following the assassination of President Lincoln, Petaluma's home guard, the Emmett Rifles, marched on its northern rival. When the contingent reached the historic Washoe

Most of the players gave off a fierce look, but dressing uniformly didn't seem to be top priority for this Sonoma County football team that played the game around the start of the 20th century. As fans with buggies watched in the background, the players worked out with an oversized ball. At a time when personal safety was a relatively low priority, some used helmets and some didn't. (Sonoma County Museum.)

House tavern halfway to Santa Rosa, it took a break for refreshments. By the time the marchers got focused on military matters, it was too late to continue. They took the dusty trail home to nurse their hangovers and curse the city to the north.

The high school rivalry of the Purple and White Petaluma Trojans and the Orange and Black Santa Rosa Panthers may have reached its peak during the 1930s and 1940s. Petaluma's obsession with eggs and poultry fueled the fire. At football games, Petaluma High School fans let it be known they were proud to be from "Chickaluma." Visitors took their revenge on the city's symbolic chicken, a giant papier-mache bird located first at the railroad station and later at the south entrance to town.

By 1938, the chicken was on display at the south entrance to town. On a cold night in late October, a bomb was planted in the chicken's innards. The great bird blew to pieces around 10 p.m., leaving patrons at the nearby Colony Club pondering what the bartender had put in their last drink. When they went outside to look, they saw bewildered motorists zig-zagging around chunks of stucco, twisted wire and sticks which littered the road. As reported the next day, the huge replica of a hen sitting on the World's Egg Basket "is no more."

A Santa Rosan, speaking many years later, said:

"We got together a bunch of guys and somebody said it would be a great idea to blow up that big, ugly chicken. If you came from Santa Rosa, that seemed like a hell of a good idea. A couple of farm boys, I can't mention their names, provided the dynamite, we got a car caravan together, and went down and planted the dynamite in the chicken."

There were no more major incidents until the Saturday afternoon season finale in 1943 when the visiting Santa Rosa football team trounced Petaluma 33-0. The game was followed by a riot on the streets of downtown Petaluma. It took civilian and military police and firemen to break up the combatants, estimated at 1,000. It started when large numbers of students, mostly girls from both schools, congregated in the vicinity of Kentucky Street and Western Avenue after the game.

JOE HARN

Joe Harn, from Petaluma High School, said:

"Some Santa Rosa girls tried to steal the purple and white sailor hats worn by Petaluma girls. Since their football team had just finished humiliating us, our girls weren't going to take any more insults from Santa Rosa. They fought back, the hat-grabbing turned to hair-pulling, and the battle was on."

BOB CHADWICK

Bob Chadwick, a junior high student, was getting ready to hitchhike home to Cotati when he saw trouble developing:

"Somebody hoisted me up into a window opening. I was able to get a full view of what was going on. The girls were really going at it . . . pulling hair and rolling on the ground."

CLARENCE BASS

The incident that apparently triggered a general melee involved a car driven by Clarence (Sam) Bass of Santa Rosa. Years later, Bass recalled:

"I was a junior in 1943, gasoline was rationed during World War II, gas stamps were needed . . . to purchase gasoline . . . It was common for all of us to chip in and share ration stamps. Ralph De Marco, Al Trombetta, Harold Bolla, Pat Hartman, Pat Rizzo, and I were all using my recently purchased green 1937 Ford Sedan, having just traded in a Model A for this jewel at the grand cost of $275.

"After the game . . . downtown main stree

Running back Bill Rogers (left) led Santa Rosa High School to a 33-0 victory over traditional rival Petaluma in November 1943. After the game, fans swarmed onto Kentucky St. in Petaluma where Clarence (Sam) Bass (right) drove into the middle of a riot. (Santa Rosa High School Yearbook.)

of Petaluma was filled with cars, horns honking, kids on the streets and sidewalks, a typical post game ritual of that day. My new pride and joy, that green 1937 Ford sedan was one, with me driving and my friends inside.

"One of the boys in my car shouted out the window to an older person walking along, calling him a '4F'er,' a derogatory term of the day indicating one was avoiding active military service . . . I believe my passenger also gave the 'high sign,' inspiring this person, namely Lee Vinolli, to come over to the car, reach in and pat me on the face, generally instigating a fight . . . Lee jumped on the running board and turned the steering wheel causing my car to run into a parked car, pushing it to the sidewalk and almost through a plate glass window of Petaluma's largest department store. Fortunately, no one on the sidewalk was hit by the car. I jumped out of my car, very upset by the damage and let Lee have a left to the stomach and right to the jaw. At this point 'All

Hell Broke Loose.' Al Trombetta rolled up the windows and was lost under the seat someplace. A fight started, easily over a thousand students involved.

"I was surrounded by a group of Petaluma students who were forcing me into an alley, one jabbed me in the mouth splitting my lip open. All of a sudden, I could see someone pushing his way through the crowd, grabbing me and saying, 'OK, SAM, LET'S GET OUT OF HERE.' He turned out to be our own football coach [Jim] Underhill. This heroic action on his part saved me from a severe beating at the hands of a riot-crazed crowd. Coach Underhill took me to Santa Rosa General Hospital, my lip was stitched . . .

"Lee Vinolli . . . did pay for the damages to my car. For some strange reason, after this incident I developed a stereotype of being a great fighter, unfortunately. This was an image I had to live down."

It was standing room only when Pat Grogans drove up in his 1926 Chevrolet Roadster for a football rally at Santa Rosa High School in the early 1940s. The Panthers enjoyed a season ending 33-0 victory over archrival Petaluma to gain a share of the North Bay League title in 1943.

LEE VYENIELO

Bass identified his attacker as Lee Vinolli, but the name was Lee Vyenielo, a sophomore at St. Vincent's High School. According to Vyenielo, who later became a football star with the Petaluma Leghorn football team of the late 1940s and early 50s, he and friends Don Ramatici and Joe Harn were milling around in the crowd on Kentucky

Street in front of Mattei's Clothing Store whe "We were cut off by Bass' car. They said som things and we said some things, our temper got hot and I jumped on the running board o his car. He didn't hit me in the jaw, he got m on the nose, and he broke it. I had to go loo for a doctor to take care of my nose."

It took the Petaluma Fire Department t end the fighting. One truck went north o Main Street and the other went north o

Kentucky Street, shooting streams of water at the crowds, forcing them to disperse.

At least two Santa Rosans, a male and a female, suffered substantial injuries, including one concussion.

"The next week," Vyenielo said, "police came to the place where I was working and asked me about what happened. Father [James] Kiely, [pastor of St. Vincent's Church and overseer of the school attended by Vyenielo], called an assembly at the high school, took a look at my nose and in front of everybody threatened to expel me from high school."

Classmate Clarice Fringle—who later became Mrs. Vycnielo—asked her mother to intercede. She did, and after a lengthy discussion, Kiely relented and allowed Vyenielo to stay in school. He was required to pay $50 damages to Bass.

His father wanted him to be a classical pianist, but Ralph DeMarco loved baseball. He played third base for Santa Rosa professional and semi-pro teams in the 1940s. (DeMarco Family Collection.)

RALPH DeMARCO ON BASEBALL IN THE 1940s

Torn between the piano and his favorite sport, Ralph DeMarco chose baseball. He played several infield positions on Santa Rosa semi-pro teams and two short-lived professional teams in the 1940s.

"I played baseball because I loved the game but after I got married I decided I loved my wife and kid more and we needed to be together on weekends.

"[The semi-pro Santa Rosa Rosebuds] had a big-time rivalry with the Healdsburg Prune Packers. We'd win one and they'd win one. One day I had a real good day. I made a couple of good plays at third. One of the Healdsburg players thought I celebrated too much . . . I guess he thought I was showing off . . . so he came out looking for a fight. His father, [a manager for the Prune Packers], told him to it down and that took care of that.

"[When I was growing up back in New York City] my dad wanted me to be a piano player but I wanted to play baseball. I studied at Carnegie Hall; I liked to play boogie-woogie. When I got to Santa Rosa, [in high school] I sat

down and played the piano during assemblies. It shocked the coaches . . . they thought the only thing I knew was baseball. Everywhere I went I played the piano after games. In those days, the hotels almost all had pianos so I could play wherever I liked.

"In the 1940s, a lot of teams from San Francisco came up to play in Santa Rosa. We had almost all home games. There were lots of leagues in those days and there were quite a few guys on the teams who made it in the pros. Our big problem was the weather. It was hot on Sundays, but at night the fog rolled in . . . I felt sorry for the fans. For awhile, I went to San Francisco to play with the Funston Tavern team. They gave me $5 for gas. We passed the hat at games but hardly anybody was paid, except maybe the pitcher.

"Pittsburgh put their farm team in Santa

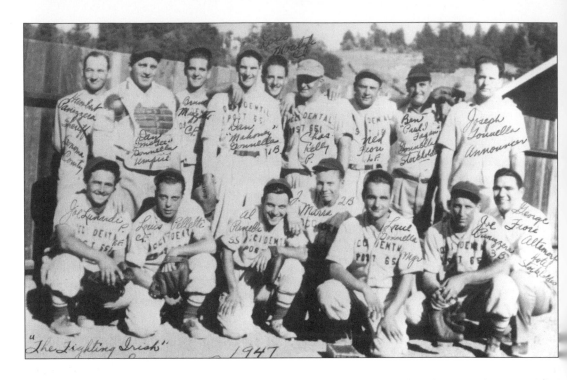

They may not have been the best semi-pro baseball team around but they may have had the best sense of humor. The "Fighting Irish," a team made up almost entirely of Italians from Occidental, finished 4th in the Sonoma County Semi-pro League in 1947. Pitcher Charles Kelly was the only certified Irishman on the team. Team members, kneeling, from left: Joe Lunardi, Louis Pelletti, Al Panelli, Chester Marra, Louis Gonnella, Joe Panizzera and George Fiori; (back row) Humbert Pannizzera, Dan "McGee" Gonnella, Bruno Mazzotti, Dan "Mahoney" Gonnella, Dario Montafi, Charles Kelly, Ned Fiori, Ben Gonnella, and Joseph Gonnella. (Sonoma County Historical Society.)

Rosa and it lasted for a year. Bing Crosby owned the club and there was a lot of publicity when he came to visit us one night at Doyle Park. The Pirates were signing a young pitcher named Vern Law, who had a real fastball, and became a big star for them. I played on the pro teams one season and they tried a second year but the team went broke and we had to quit in mid-season."

THE MIGHTY LEGHORNS

Gene Benedetti was a tough little guy who had the right stuff when it came to fighting wars, playing football or coaching Petaluma's semi-pro "dream team" after

World War II. Benedetti, born in rural Cotati in 1919, first made his mark as a star center and quarterback at Petaluma High School, Santa Rosa Junior College, and University of San Francisco.

Benedetti joined the Navy in 1942, serving heroically in North Africa, Italy, and at the D Day landings in Normandy. His inspiration came partly from his brother Dan, a teacher and coach whose plane was shot down over Guadalcanal in 1942. His body was never found.

Benedetti thought he was headed home after the Italian campaign, but he was called to take part in the D-Day invasion June 6 1944. He was told he would be taking landing craft to a "dead beach" where there

was no enemy resistance. Instead, when he guided his landing craft to Omaha Beach, it turned out to be "the worst day of my life." He found himself under heavy attack from German guns, losing four of his crew and many men on board. To get the three tanks aboard off, he had to manually pull down two 300-pound ramps that had been damaged. Benedetti hurt his back and suffered minor wounds, but stayed 35 more days to deliver men and equipment.

When Benedetti got home, he and a few friends decided to put together a football team for a one-time Armistice Day game in 1946 against the USF Ramblers. It was the start of a magical era for the Leghorns. When a large crowd turned out, it was decided the team would play a full schedule in 1947. Benedetti, the team's first coach, led the Leghorns to a remarkable era of success. From the beginning, support for the team was intense, partly because a large number of local players were on the team and partly because the professional San Francisco 49ers had not yet gained a loyal following. Faithful Leghorn fans commuted from Ukiah and beyond to watch the team in action. Pro football pushed club football aside in the 1950s, but in their heyday, the Leghorns ruled the roost.

LEE TORLIATT ON THE LEGHORNS

The Leghorns often won by big scores and when a game was out of reach of the opposition, it became a tradition for fans to call for linemen to move into the backfield to score a touchdown. Chants of "Ghi-Lot-ti" and "Ri-Dol-Fi" went up until coach Benedetti called on guard Mario Ghilotti or tackle Dante Ridolfi to play fullback at the goal line. Once, on his birthday, tackle Butch Burtner was sent in to score the last touchdown.

The Leghorns' arrival intensified the sports rivalry between Petaluma and Santa Rosa. In their first meeting, the Leghorns crushed the Santa Rosa Bonecrushers 77–0 in a game played in Petaluma in 1947. The next year, the Petalumans made an infrequent road trip to

Leghorn running back Bob Acorne and Coach Gene Benedetti remained active in the community, selling tickets for charity events. (Petaluma Library History Room.)

Quarterback Fred "The Fox" Klemenok quarterbacked the team during its best years, and went on to become a car salesman in his hometown. (Petaluma Museum.)

When local servicemen returned from World War II, they decided to stay active by playing semi-pro football. The Petaluma Leghorns turned into a powerhouse during the late '40s and early '50s. Working on basics at a night practice were Don Head, Al Pisenti, Lee Vyenielo, and Bud Chadwick across the line and Fred (The Fox) Klemenok, Stan Mohar, and George Legorio in the backfield. (Petaluma Museum.)

Nevers Field in Santa Rosa for a rematch. Leghorn fans watched in disbelief as the Crushers won an upset victory, 14–13. After the game, rumors circulated that Santa Rosa had wet down the playing field and worn mud cleats to gain an advantage. Surely, pure talent was not the issue: in that case, the Leghorns would have won easily.

As their popularity grew, tackle Burtner came up with the idea of playing a season-ending game for charity and calling it the Egg Bowl.

By 1949, Benedetti had put together a solid team led by quarterback Fred "The Fox" Klemenok, another Petaluma star who played at USF. The team won 12 games, lost one and tied one, beginning a streak of 26 games without a loss. The team accepted an invitation to play in the Fruit Bowl at Kezar

Stadium in San Francisco against the Oakland Devils. A thousand Petaluma fans took advantage of the offer of a ticket and bus ride to the game for $3.50. The 59,000 empty seats left plenty of room for seagulls. Huddled around the 50-yard line, fans watched their team win 33–13, and then follow up with a victory in the Egg Bowl.

In 1950, Benedetti, a rising executive at the Petaluma Cooperative Creamery, faced a difficult choice. Because of time pressure, the team's first coach decided to retire, taking with him a record of 40 wins, 6 losses, and 2 ties over 4 seasons.

Don Ramatici, later a successful insurance man, took over in 1951, minus quarterback Klemenok, who had been called back to military duty during the Korean War. Frank VanHoutte, a long-distance passer from Sar

Francisco, replaced Klemenok. When VanHoutte failed to show up for a game, Bob Baskett, sports editor of the Santa Rosa *Press Democrat*, tracked him down at a duck blind in the Sacramento Valley.

The next year, Klemenok returned and led the Leghorns to 11 victories against only one loss. The team continued to play into the late 1950s, but it would never again match its early record.

Benedetti became co-owner and president of Clover Stornetta Farms in 1977, an organization that docs more than $30 million a year in milk business around the San Francisco Bay Area. In spite of Clover's success, friends say Benedetti has never lost the small-town touch that made him such a favorite as a player and coach. The milk firm is well known for dishing up free ice cream at the Sonoma County Fair and other community events, sponsoring symphony concerts for school children and other charity activities. Using the symbol of "Clo the Cow,"" the organization has plastered North Bay billboards for many years with humorous illustrations such as Clo hovering around the tennis net at "Center Quart." In another ad, Clo, in a trenchcoat, gives her best imitation of Humphrey Bogart in the movie "Casablanca" with a message that says, "Here's Lickin' at You, Kid."

Leghorn tackle Butch Burtner (center) came up with the idea of playing an Egg Bowl charity game. His arguments were taken serious since he loomed over most teammates, including Mario Ghilotti (left) and Kenneth White (right). (Petaluma Library History Room.)

BIBLIOGRAPHY

Carpadus, Norman and Kitty Carpadus. *A History of the Petaluma Fire Department, 1857 to 1963*. Published 1964.

Dry Creek Neighbors Club. *Vintage Memories*. Published 1979.

Edwards, Don. *Making the Most of Sonoma County*. Valley Moon Press. Published 1986.

Eitelgeorge, Jack. *Sons of Sondrio, History of the Pedroncelli Family.* Published 1997.

Fraire, G.A. *I Remember Healdsburg*. Published 1993.

Fratini, Ed. Radio Station KTOB Broadcast Transcripts, Nov. 6, 1980; Apr. 28, 1981; Aug. 6, 1981; and Aug. 18, 1983.

Healdsburg Tribune, various editions, 1880 to 1906.

Heig, Adair. *History of Petaluma, A California River Town*. Scottwall Associates, 1982.

Hoods, Holly. Interview with Louis J. Foppiano excerpted from *A Century of Winegrowing in Sonoma County, 1896–1996*. Published 1996.

Huie, William Bradford. "A Jap Discovers America." *American Mercury*, Feb. 1944, pp. 216–220.

Lewis Publishing Co. *Illustrated History of Sonoma County*. Published 1889.

LeBaron, Gaye, Dee Blackman, Joann Mitchell, and Harvey Hansen. *Santa Rosa: A Nineteenth Century Town*. Published 1985.

LeBaron, Gaye and Joann Mitchell. *Santa Rosa: A Twentieth Century Town*. Published 1993.

McNeill, James. "Bunion Derby." *Siskiyou Pioneer*, 1969, pp. 5-11.

Munro-Fraser, J.P. *History of Sonoma County*. Published 1880.

Ott, George. Typescript Memoirs, date unknown.

Petaluma Argus, *Petaluma Courier*, and *Petaluma Argus-Courier* newspapers, various editions, 1856 ff. to 1967.

Petersen, Geraldine and Dan Petersen. *Santa Rosa's Architectural Heritage*. Published 1982.

Prince, William Stevens. *Crusade and Pilgrimage*. Published 1986.

Russian River Recorder. Publication of Healdsburg Museum and Historical Society, various issues, 1985–2001.

Sanders, Garth. "Mad Bull's Run for Glory." *San Francisco Examiner and Chronicle*, Apr. 8, 1984, pp. 27-28.

Santa Rosa Press Democrat and *Santa Rosa Republican*, various editions, 1880 to 1997.

Smith, Hannah Ward Stewart. "True Story of a True Woman." White House Department Store Bulletin, Feb. 1931.

Sonoma County History Society Journals, June 1963 ff.

Wharff, David. *Letter to A.P. Behrens*. Apr. 26, 1918.